THE ESSENTIAL ™

Johannes Vermeer

BY CHRISTOPHER SWEET

THE WONDERLAND PRESS

Harry N. Abrams, Inc., Publishers

THE WONDERLAND PRESS

The Essential™ is a trademark
of The Wonderland Press, New York
The Essential™ series has been created by The Wonderland Press

Series Producer: John Campbell
Series Editor: Julia Moore
Project Manager: Adrienne Moucheraud
Series Design: The Wonderland Press

Library of Congress Catalog Card Number: 99-73514
ISBN 0-7406-0290-4 (Andrews McMeel)
ISBN 0-8109-5801-5 (Harry N. Abrams, Inc.)

Distributed by Andrews McMeel Publishing
Kansas City, Missouri 64111-7701

Unless caption notes otherwise, works are oil on canvas

Printed in Hong Kong

Harry N. Abrams, Inc.
100 Fifth Avenue
New York, NY 10011
www.abramsbooks.com

Contents

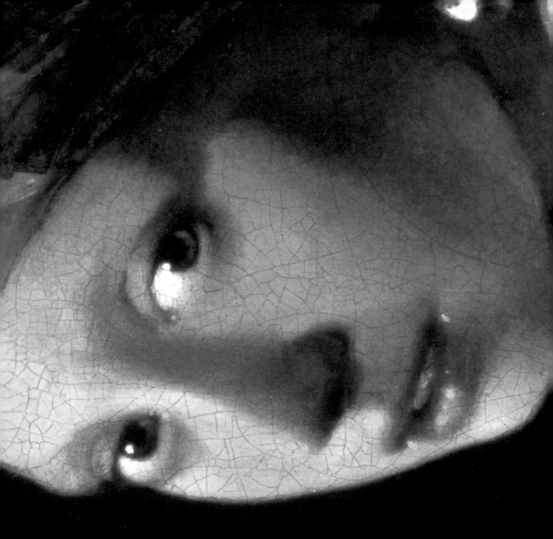

A Blockbuster Hit!

To no one's surprise, the Vermeer exhibition at the National Gallery in Washington, D.C., in 1995 was a smash hit with thousands of people—one of the most popular and memorable museum shows of the late 20th century. Perhaps more of a surprise, however, were the *types* of crowds attracted to the blockbuster event—crowds consisting of punk rockers, working moms, senior citizens, screaming children, secretaries, bikers, and an endless parade of curiosity seekers. Vermeer! The great Dutch realist painter of the 17th century whose works long languished in obscurity, unknown and eclipsed by his fellow Dutch painters Rembrandt and Frans Hals. Indeed, Vermeer!

The Mysterious Dutchman

So little is known about Vermeer's life that anyone viewing his paintings for the first time knows almost as much about him as the world's leading authorities on the painter. (We have only paintings by Vermeer; no drawings or etchings by Vermeer have survived, if they ever existed.) Not only is little known about his *life*, but for generations his *work* remained obscure as well. Vermeer virtually vanished as an artistic personality for nearly two centuries, only to be resurrected to universal acclaim in the 19th century. Why do you suppose that his paintings

were only modestly successful in his lifetime but resonate strongly with today's viewers? In part, it's because of his technique, use of color, and visual perspective, but also because of the tantalizing glimpse he offers of his small world.

We know nothing of his education, his training or teachers, his personality, his goals, or his dreams as an artist. Apart from a few notations in pubic documents, we know *nada* about Vermeer. The facts are few and blunt: baptism, marriage, children, deaths in the family, debt upon debt, a few minor distinctions, his own death, and long disregard.

Unlike other artists (e.g., Vincent van Gogh or Jackson Pollock), whose personal lives make for great narratives, Vermeer comes alive not through facts or biographical data, but through the inferences we must make from his paintings. While the 35 known Vermeer paintings stand on their own as works of art to be appreciated for their creative merits, they also invite us into the quiet chambers on the canvas and tempt us to search for meaning in the poignant, simple world of Vermeer's people.

Since the paintings are all we have, they are our key to understanding Vermeer. Enjoy them, savor their mysteries, and in a couple of hours you'll know more about this amazing painter than almost everyone at the next big Vermeer show. This book contains every painting attributed to the artist, so enjoy!

Vermeer's Little Corner

Certainly Vermeer the artist gives us clues about Vermeer the man. But, more important, his works shed light on something profound about a quiet corner of the human experience—namely, the beauty of moments of solitude and reflection. Vermeer achieves a kind of monumental grace through a mastery of painterly techniques, yet his images possess a personal charm, meaning, and simplicity with which *we* can identify. However subtle or elusive his meanings, they resonate with our own yearnings and private thoughts, and are thereby as relevant in the 21st century as they were 400 years ago.

FYI: Vermeer's Name and Signature—Over the years Vermeer has been referred to variously as Jan Vermeer, Johannes Vermeer, Jacob van der Meer, and Jan Van der Meer. These variations have corresponded roughly to our growing knowledge of the artist. Jan is a familiar term for Johannes, which may have been used by his wife, but now seems inappropriate—like calling Leonardo da Vinci "Leo." On official documents, Vermeer signed himself Johannes Vermeer, but on his paintings he used a variety of signatures.

Meer.

M

i·Meer

Meer

iM.

I·Meer.

iMeer.

The meditations of his subjects, at once intimate and aloof, invite us to contemplation. The perfect balance of design, the vibration of color, the caress of light, and the strange familiarity of the domestic interior, of the pensive woman, of the hour and minute transfixed, bestow a purity and harmony and mystery rare in art. Vermeer's paintings reveal him as an artist of his age—and for all ages.

The Artist's Parents

So.... What do we know about him? On October 31, 1632, Johannes Vermeer was christened **Joannis** in the New Church (Nieuwe Kerk) in Delft, located in the Low Countries (now known as Belgium and the Netherlands). He was the second child and only son of **Reynier Jansz** (1591–1652) and **Digna Baltens** (no dates). Reynier Jansz was a weaver (*kaffawercker*) who had been born in Flanders and had moved with his family to Delft by 1597. Vermeer's mother was born in Antwerp in the late 1590s, and soon afterward her family moved to Amsterdam. The two were married in Amsterdam in 1615. Their first child, Vermeer's sister, was baptised **Geertruijt** in Delft on March 20, 1620.

Sometime after 1620, Vermeer's father began using the name Vos, and from about 1627 to 1630 he kept an inn on the Voldersgracht (in Delft) that he called The Flying Fox (De Vliegende Vos). At some point, perhaps working out of his inn, he took up art-dealing, and on October 13, 1631, he joined the Delft **Guild of Saint Luke** as a

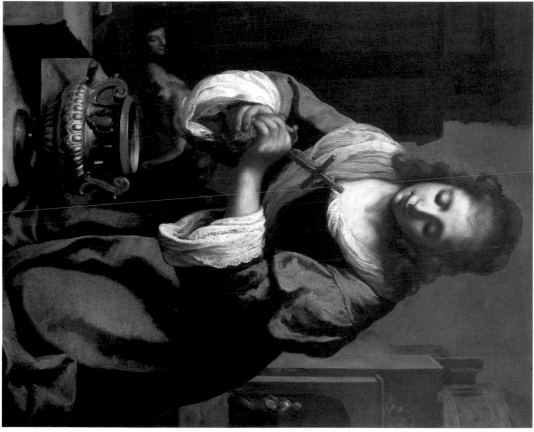

Master Art Dealer. A little over a year later his son was born. A document dated September 6, 1640, shows Reynier Jansz Vos using the name Vermeer. In 1641, Reynier was sufficiently prosperous to be able to purchase the Mechelen Inn on the market square of Delft, where he also continued to conduct his art-dealing activity. He died on October 12, 1652, and was buried in Delft.

That's about all we know of mom and dad. There was a skeleton in the closet concerning Vermeer's maternal grandfather—he was involved in a counterfeiting plot—but his parents appear to have led respectable lives and we may surmise that they adored their son, the baby of the family, who came to them rather late in life.

In virtually every book on Vermeer, you'll see words like *perhaps* and *maybe* and *possibly* (e.g., Maybe Vermeer studied with...). Since nothing is known for sure, everything is conjecture, so trust your own instincts while viewing his art and feel confident about reaching your own conclusions.

Context: The Dutch Republic

Dutch art of the 17th century was a bit unusual when compared with what was being created in other countries at the same time. It was the first art produced largely for middle-class consumption, and you'll understand this better if you know something about how the Dutch Republic emerged.

The Spanish Invasion—or, Those Darned Spaniards!

While Spain is a fairly low-key country today, it wasn't that way in the early 1500s during the Protestant Reformation, when the Low Countries came under the rule of Charles I of Spain, a fervent Catholic. He would become king of Spain in 1516, emperor of Germany in 1519, and, as emperor of the Holy Roman Empire, he would be known as Charles V. By 1555, when Charles abdicated in favor of his son, Philip II, he would rule over nearly the whole of continental Europe. The Spanish court's primary interest in this northern possession was to obtain revenue and to crush Protestant heresy. The northern provinces had embraced Calvinism (the doctrines of John Calvin, a leader in the Protestant Reformation, which emphasized predestination, the sovereignty of God, and the supreme authority of the Scriptures) while the southern provinces remained largely Catholic.

A devout Catholic, Philip was determined to carry out the decrees issued by the Council of Trent in 1543, which had launched the Counter-Reformation. (The Council of Trent consisted of leaders in the Roman Catholic Church who met intermittently from 1545 to 1563; they defined church doctrine and condemned the Protestant Reformation.) Philip dispatched the Duke of Alva to the Netherlands to subdue any inclination toward independence in wealthy Flanders and to impose the Inquisition (i.e., the dictates of Roman Catholicism) on "heretical" Holland.

In 1568, the Low Countries united under the leadership of William the Silent, Prince of Orange, and rebelled against Spanish rule, thereby initiating the Eighty Years War. (Stay with us here; it's important to know that the Low Countries were fraught with conflict and would later value their freedom and independence.) Later, in 1579, the Union of Arras was signed by the Catholic provinces of Hainaut, Artois, and Douai, thus affirming their loyalty to Philip; in response, the seven northern Protestant provinces would sign the Treaty of Utrecht, which formed a military union against Spain and would soon become the Republic of the United Provinces. This fierce and bloody struggle went on until 1609, when Spain signed the Twelve Years' Truce.

Although hostilities resumed after the truce ended, the Dutch Republic was not seriously threatened again. The Treaty of Westphalia of 1648 would officially end the war, and with it came formal recognition of the United Provinces. The south, where much of the fighting had taken place, remained under Spanish rule and became impoverished, while the north prospered and was free and independent.

**BACKTRACK
PLACE NAMES**

Modern-day **Belgium** and the **Netherlands** (also known as **Holland,** after its largest province) can be referred to collectively as the **Low Countries.** In the 16th century they were also referred to as the **Spanish Netherlands.** The southern provinces that comprise Belgium are largely Roman Catholic, whereas the northern provinces that became the Netherlands embraced Protestantism at the time of the Reformation. The Netherlands are also known as the **United Provinces** and the **Dutch Republic.**

From the 16th century until well into the 17th century, the Netherlands was a strong maritime power. Its overseas exploration and trade, as well as its strategic position on the continent, gave rise to a rich mercantile economy. With Spain out of the picture, the Dutch were able to throw themselves energetically into their maritime enterprise and other pursuits. In this climate of tolerance, the Netherlands attracted English Puritans, Mennonites, and Jews, as well as Catholics. The country flourished economically, socially, intellectually, and artistically with its acceptance of diversity. The truce of 1609 not only brought a new era of prosperity to the Netherlands, but also marked the dawn of the Golden Age of Dutch art.

The Golden Age of Dutch Painting

In a region where previously there had been few artists, an abundance of artistic talent seemed suddenly to emerge. The three phases of art in the Dutch Golden Age are represented by its three greatest artists: **Frans Hals** (c. 1580–1666), **Rembrandt van Rijn** (1606–1669), and **Johannes Vermeer** (1632–1675).

Sound Byte:

"Some day you must assert that the only painters were Velázquez, Frans Hals, Rembrandt, and Van der Meer of Delft, a tremendous man."

—JOHN SINGER SARGENT, American painter, 1884

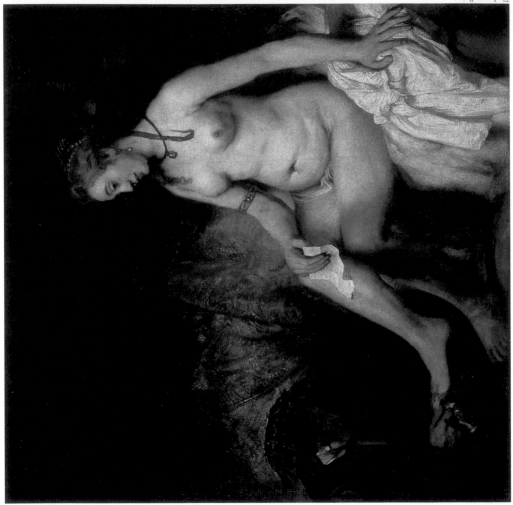

Frans Hals was the first great painter of the Golden Age. He was a portraitist famous for his bravura technique and for his ability to capture a subject's likeness. The faces that look out from his canvases are vividly individual and full of personality. Rembrandt is the towering figure of the Dutch Golden Age. In a career that lasted more than 40 years, he tackled a wide range of subject matter. He was a master of histories—biblical and mythological scenes—of portraiture, of landscape, and of drawing and printmaking.

Vermeer, the youngest of the three, came late to the scene. Around the time he began painting, the sober villagers, simple pleasures, and pride of country of the first half of the century gave way to a trend toward luxury and refinement. As the last great painter of the age, Vermeer was not an innovator in the obvious sense. His subject matter was common among the painters of his day, yet he brought to it a subtlety and purity that make his art mysteriously incongruous with that of his contemporaries. Even so, he summons up something at once essentially Dutch and profoundly universal, as we will see.

What's to See in Dutch Art?

Dutch art provided an unprecedented portrayal of a people and their world—the cities and towns, domestic life and social activity, rich burghers and rowdy peasants, ships in port and at sea, snug little farms, the sweep of the landscape, and the vast and changing skies overhead.

Without the church and aristocracy as sources of patronage, Dutch painters became dependent on middle-class society and the marketplace for their livelihood. The Protestant Church, with its bare, whitewashed walls, was not a source of commissions, and so artists who had no talent for, or inclination toward, portraiture turned to other subject matter that could be easily grasped and would be appealing to the tastes of the Dutch bourgeoisie.

Owing to the economics of the situation, artists tended to specialize in subject matter that attracted buyers. And so **genre subjects**—scenes from everyday life—flourished. It was a descriptive art, as if a mirror were being held up to their world. But just as it delighted the eye with a pleasing self-portrait, it also spoke to the values of the people.

The Dutch were less interested in the great narratives of myth and religion and the actions of kings and heroes that dominated art in Europe than they were in a more worldly, personal, as well as civic-minded art: Their art richly expressed the national feeling of the young Dutch Republic. Vermeer, one of the great artists of history, would succeed in terms of the latter, but would have a rather spotty go of it in terms of making money.

Overshadowed by Hals, Rembrandt, and Vermeer, many other notable artists brought an unprecedented depth and range to the Dutch school. These artists include painters **Jan Steen** (c. 1626–1679), **Pieter**

Saenredam (1597–1665), **Gerard ter Borch** (1617–1681), and a host of others. Favored genre subjects included landscape, marine and architectural subjects, scenes of domestic and social life, and still life.

Although the careers of Hals, Rembrandt, and Vermeer spanned a period of about three-quarters of a century, the three died within ten years of one another, all in financial distress and relative obscurity. Only Rembrandt's fame would survive his death; Hals and Vermeer would be largely forgotten until the 19th century. With the deaths of these artists, the Golden Age of Dutch art came to a close.

Opposition to the Marriage

Not yet 20 years old, Vermeer married **Catharina Bolnes** on April 20, 1653. Earlier in the month, he had formally registered his intentions to marry her, and the document was co-signed by the painter **Leonard Bramer** (1596–1674) and one

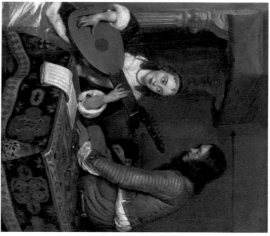

Gerard ter Borch
A Woman Playing the Theorbo for a Cavalier, (n.d.)
Oil on wood
14 ¹/₂ x 12 ³/₄"
(36.8 x 32.4 cm)

Captain Bartolomeus. But already there was trouble in paradise: Catharina's mother, **Maria Thins**, refused to sign the document granting her consent to the marriage. The witnesses stated, however, that Maria did finally agree to allow the engagement to be announced and the wedding to take place.

Interestingly, Maria Thins, a Catholic, had divorced her own husband, **Reynier Bolnes**, in 1641, but was financially well off and socially well connected. Her opposition to her daughter's marriage may have been for social, financial, or religious reasons (it is alleged that Vermeer had converted to Catholicism only days before the wedding). Nonetheless, the wedding took place in the small, predominantly Catholic village of Schipluy, about an hour's walk south of Delft. Johannes and Catharina began their married life in Mechelen, and would ultimately have 15 children—four of whom would die in infancy.

A Sorcerer's Apprenticeship?

Vermeer registered as a painter in the Guild of Saint Luke on December 29, 1653. He was unable to pay the full entrance fee and did not pay off the balance until about three years later. (Obviously, his mother-in-law's concerns were not entirely unfounded.) According to standard practice, Vermeer's apprenticeship would have lasted about six years, so he probably began his formal training in the late 1640s. It is generally assumed that Vermeer studied in Delft, but there is no record of his

presence there between his baptism in 1632 and his marriage to Catherina Bolnes in 1653. Nor is there any record of his apprenticeship or of his teachers. Leonard Bramer and **Carel Fabritius** (1622–1654), though unknown to most people today, are the two painters usually suggested as his probable teachers. There are no documents linking Vermeer directly to any artists other than Bramer and ter Borch. Any influence of ter Borch that Vermeer may have felt did not show in his work for many years, and so it is highly unlikely that ter Borch was his master. Leonard Bramer was one of the leading artists of Delft in his day and for an ambitious young artist, Bramer would have been a useful connection. But despite the documentary link to Vermeer, their work shows no kinship stylistically.

FYI: The Guilds—Guilds had developed in medieval times as a form of trade association, protecting the interests of merchants and artisans. Saint Luke is the patron saint of artists and so, appropriately, the Guild of Saint Luke was an organization for artists and others associated with the arts. In Delft, the guild included weavers and art dealers, stonecutters, potters, and booksellers, as well as artists. About six years of training with a member of the guild was required of new members. Vermeer's membership as Master Painter was recorded in the Guild Book on December 29, 1653. Fellow members included Leonard Bramer, Pieter de Hooch, Carel Fabritius, and others. Vermeer was twice elected head of his guild.

The Works and Influence of Fabritius

The second artist often proposed as Vermeer's artistic mentor was Carel Fabritius, the artist most closely associated with Vermeer in the early 1650s. After studying with Rembrandt in Amsterdam, Fabritius moved to Delft around 1650. He was full of promise—a brilliant, original painter—but he died prematurely in the explosion of the Delft powder magazine that destroyed a large part of the city on October 12, 1654.

Fabritius's known output is small, but from the works that survive, it is clear that Fabritius had a large influence on the younger painter. However, evidence that Vermeer admired and learned stylistically from Fabritius appears in Vermeer's work only after Fabritius's death.

The surviving works that are unquestionably by Fabritius are portraits and genre scenes. Early on he was still much under the influence of Rembrandt, as seen in his *Self-Portrait* of 1648. There is a warmth of color, rich brushwork, and dramatic play of light and dark. In Delft, however, Fabritius's palette changed to a cooler range and his paint texture thinned and became more transparent. This shift can be seen in such works as *The Goldfinch* (1654) and *The Sentry* (1654). Also characteristic of the Delft work was the depiction of a single figure against a light, glowing background; the skillful rendering of intimate, architectural space; and the choice of a simple subject with a concentrated meaning. Fabritius was also a master of perspective and was

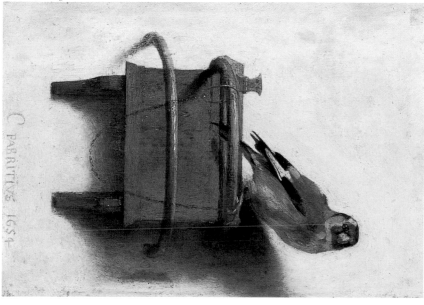

ABOVE
Carel Fabritius
The Sentry, 1654
26 ³/₄ x 22 ⁷/₈"
(68 x 58 cm)

LEFT
Carel Fabritius
The Goldfinch
1654. Oil on panel
13 x 9"
(33.5 x 22.8 cm)

fascinated by optics—an interest shared by Vermeer, as we will see when we look at the role of the *camera obscura* in his work (see pages 53 and 93).

The Mother-in-law

Through the mid-1650s, Vermeer signed at least three documents related to debts he had incurred. In 1657, Vermeer's mother-in-law drafted a will leaving her jewelry to her granddaughter and namesake, and she lent 300 guilders to her daughter and son-in-law. By 1660, Vermeer and his family were living in the home of his mother-in-law. Despite her early reservations, it seems that Maria Thins eventually took to Vermeer. His conversion to Catholicism and his sympathy for women, as evidenced in his paintings, seem to have outweighed his precarious finances in his mother-in-law's estimation.

Vermeer's First Known Paintings

There are no known works by Vermeer dated before 1655. The earliest Vermeer paintings that exist, we can tell that Vermeer's original inclination was to work in an international, or **Italianate,** style of painting. Definite similarities exist between his two paintings *Christ in the House of Martha and Mary* (c. 1654–55) and *Diana and Her Companions* (c. 1655–1656) and the paintings of the Utrecht School, particularly those by the artist **Hendrik ter Brugghen** (1588–1629). So it is clear that whether or not he actually traveled—

which is not known, though certainly paintings were portable—Vermeer looked beyond the local traditions of Delft to artistic currents elsewhere to inform his art.

FYI: History Painting—In terms of subject matter, history painting was considered the highest category of art in Vermeer's time. It included biblical and mythological subjects, the lives of the saints, and scenes from ancient history. The genre was considered superior to portrait painting, landscape, and still life.

Christ in the House of Martha and Mary is Vermeer's first major surviving work. It is the largest painting of his known oeuvre, and was thus possibly painted on commission. It is Baroque in its fullness of form, its flowing movement, and its loose handling of paint. The contrast of light and shadow from a lamp or a fire gives it an expressive force. The painting possesses an intensity of feeling even as it represents the religious scene in a direct, almost earthy manner.

The work also speaks to **Vermeer's conversion to Catholicism.** The subject matter was more typical of Catholic Flanders than of the northern Protestant provinces. It tells the story from Luke 10:41–42, where Christ visits the sisters Mary and Martha. Martha is busily attending to the needs of her guest while Mary sits at the feet of Jesus to receive his teaching. Vermeer has composed the figures in an intimate

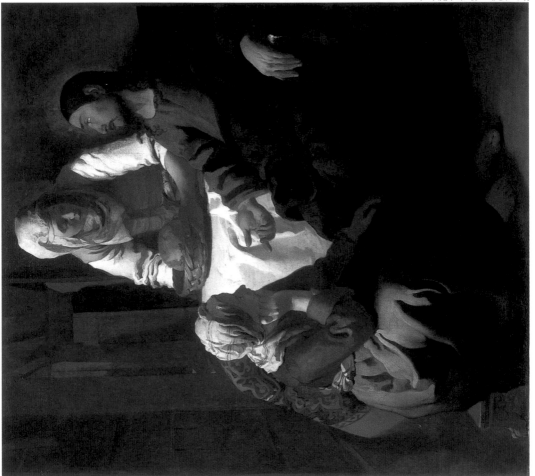

circle, presenting the active life (Martha) and contemplative life (Mary) in close proximity to the Christ figure, with the contemplative life favored. And, indeed, the ideal of the contemplative would be favored throughout the surviving works of Vermeer.

The mythological scene of *Diana and Her Companions* (on p. 27) is a melancholy work that links the young Vermeer with the Utrecht School and the Rembrandt school in Amsterdam, and it indicates his ambition to join the great European tradition in the Italianate style. The piece was originally attributed to **Nicolas Maes** (1634–1693), but it was later determined that the apparent remains of a signature "N. M." had been added to the painting over the obscured remains of a signature "J V Meer." Its clear similarities to *Christ in the House of Martha and Mary* and *The Procuress* in color and paint-handling confirm the attribution to Vermeer.

Diana, the virgin goddess of the hunt, was the pagan embodiment of chastity. She is identifiable by the animal pelt around her waist and the crescent moon mounted on her head—symbolic of her role as goddess of the night. Vermeer has fused the pagan motif with Christian symbolism through:

■ the washing of the feet, just as Jesus did for his disciples the evening before his crucifixion;

■ the thistle in the foreground, a Christian allusion to sin and sorrow, especially when coupled with the thorn;

OPPOSITE
Christ in the House of Martha and Mary
c. 1654–55
63 x 55 7/8"
(160 x 142 cm)

25

- the nymph, beside the goddess, who clutches her foot—an indication of the thorn, which symbolizes Christ's suffering.

Diana's aspect as goddess of the night also associates her with death. Note: *Vermeer primly avoided any significant exposure of flesh.* He never succumbed to the opportunity to paint a nude, even though it is thought that he modeled the central figure of Diana and her kneeling attendant on Rembrandt's *Bathsheba* (on page 14). His treatment of the painting, the *impasto* brushwork (i.e., the thick laying on of paint) and use of shadow, especially across the faces of the figures, also indicate a familiarity with Rembrandt's work.

Painted not long after the Delft explosion on October 12, 1654, *Diana and Her Companions* has been seen as a kind of elegy to those killed in the disaster. It is also a tribute to the courtly traditions of Delft and to the Italianate style of painting that Vermeer here embraces but then abandons in favor of a more thoroughly Dutch artistic vision.

Becoming the Vermeer We Know and Love

It is with *The Procuress* of 1656 that Vermeer turns in the direction that will define his art as we know it. The painting retains characteristics of the Utrecht School that favored such scenes. Van Baburen's *Procuress*, owned by Vermeer's mother-in-law, appears in two of Vermeer's later paintings and may have been the immediate inspiration for the picture. Vermeer's version has other features in common with these painters'

OPPOSITE
Diana and Her Companions
c. 1655–56
38 ¼ x 41 ⅜"
(98.5 x 105 cm)

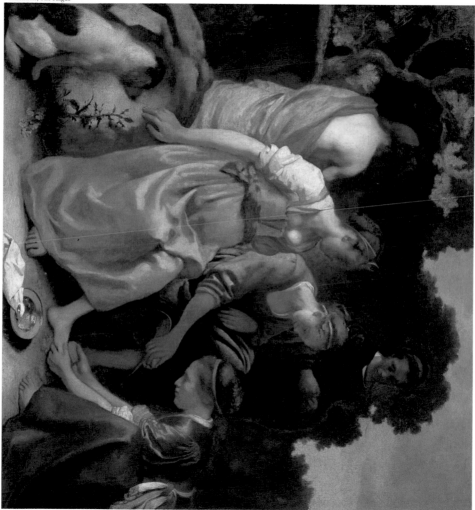

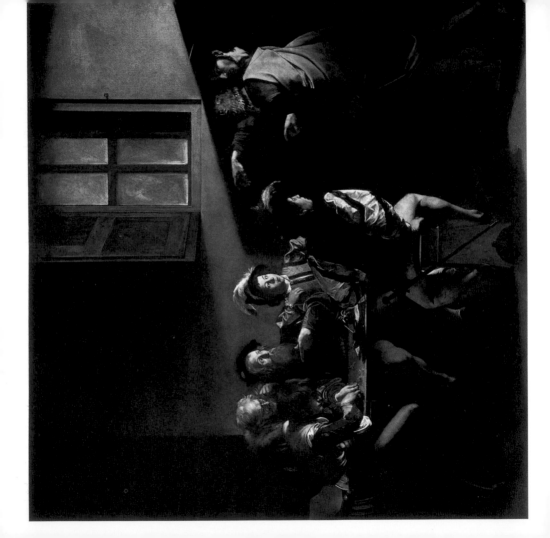

BAROQUE ART

Baroque art prevailed in Europe in the 17th century. It originated in Italy and stressed an overall unity through the use of sweeping curves and slashing diagonals and by means of a massing of light against dark, and physicality paired with void. It was expressive, often turbulent, and stressed the dramatic moment. Baroque art was essentially a Roman Catholic art and its development coincided with the Counter-Reformation. In many ways, Baroque art was used to advance theological principles of the Counter-Reformation. The preeminent northern Baroque painter was **Peter Paul Rubens** (1577–1640) of Antwerp, a master of history painting in the grand manner. Other major Baroque painters include the Italian master **Michelangelo da Caravaggio** (1571–1610), the French artist **Nicolas Poussin** (1594–1665), the Spaniard **Diego Velázquez** (1599–1660), and, of course, the Dutch painter **Rembrandt.** Baroque art flourished especially in countries under the influence of the Counter-Reformation; it is characterized by elaborate (and sometimes grotesque) forms and ornamentation, often of a religious nature.

CARAVAGGIO'S FOLLOWERS

Caravaggio was one of the most influential painters of the early Baroque period, and his many followers were referred to as *Caravaggisti*. Artists were drawn to his dramatic *chiaroscuro*—the strong contrast of light and dark—and to his vigorous naturalism, which captured such details as dirt under the nails, leathery skin, and broad facial expressions. This realistic quality appealed immensely to the Dutch. Caravaggio abandoned Renaissance idealization and gave artists a new way to look at the world and to represent it. But the Dutch also brought to this new approach something of their own: an intimacy in scale and feeling, and genre subjects in lieu of history painting. The principal Dutch followers of Caravaggio were **Hendrick ter Brugghen** (c. 1588–1629), **Dirck van Baburen** (c. 1590/5–1624), and **Gerrit van Honthorst** (1590–1656). Each had spent several years in Italy before coming home to the Lowlands, where their influence was felt by Hals, Rembrandt, and Vermeer. Through these Utrecht painters we can glean a connection to Caravaggio in Vermeer's formative years. (See overleaf for ter Brugghen's *Saint Matthew's Vocation* and Pieter de Hooch's *A Dutch Courtyard*.)

OPPOSITE: Michelangelo da Caravaggio, *Saint Matthew's Vocation* 1597–98. 111" x 115" (338 x 348 cm)

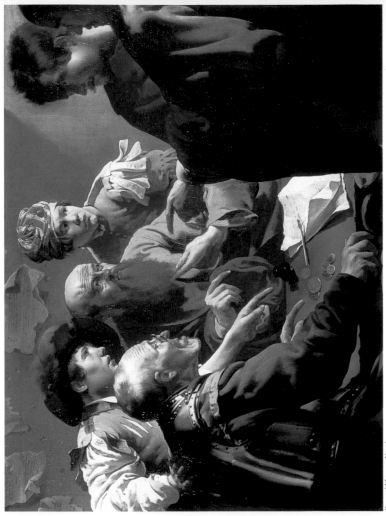

Hendrick ter Brugghen
Saint Matthew's Vocation
1621. 40 x 54"
(102 x 137.5 cm)

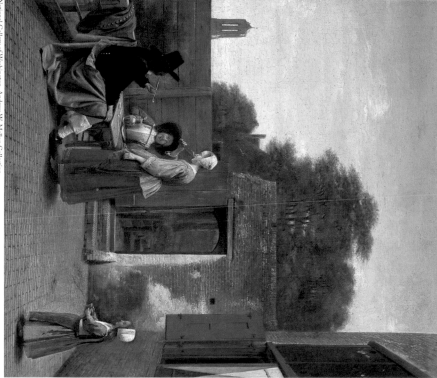

Pieter de Hooch
*A Dutch
Courtyard*
c. 1660
26 ³/₄ x 23 ¹/₄"
(68 x 59 cm)

OPPOSITE
The Procuress
1656
56 1/8 x 51 1/8"
(143 x 130 cm)

Utrecht work as well: the hint of a biblical theme, the soft candlelight glow, and the half-length figures gathered around a table. But Vermeer and other representatives of classic Dutch genre painting—ter Borch, **Frans van Mieris** (1635–1681), **Gabriel Metsu** (1629–1667), and **Pieter de Hooch** (1629–1683)—depicted such scenes in a more realistic style.

The theme of prostitution is common in Dutch art. The subject may have derived from depictions of the Prodigal Son squandering his inheritance in riotous living. It is speculated that the figure on the left in *The Procuress*—the one with the leering smile and the face in shadow but for a Rembrandtesque glancing light across the cheek—is **Vermeer's self-portrait.** At the same time that Vermeer uses the established representative scheme, he is also breaking free of it, bringing to it his unique vision, his passion for surfaces, and the optical play of light. But he is not yet altogether himself: The spatial arrangement is awkward, the carpet gathered at the front of the table hangs unconvincingly down the side, and the perspective of the table seems at odds with the figures. This intervention of a carpet-covered table between the viewer and the human subject in *The Procuress* will become a standard device in Vermeer's paintings in establishing a discreet distance between the observer and the observed.

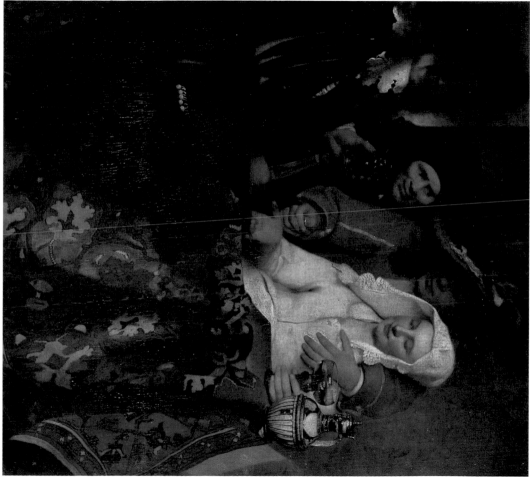

Zzzzzzzz!

A carpet appears again in Vermeer's next picture, called *A Girl Asleep*, but in this work Vermeer has resolved the spatial organization of the scene to achieve a subtle but complex composition that enhances the interpretive possibilities. Here we see a well-dressed woman, probably the woman of the house, seated at the table. She rests her weary head on her hand and her eyelids are closed, as if in sleep or meditation. The remnants of some revelry are strewn across the table—a wine jug and glass, an overturned glass goblet, a plate of fruit, a tousled cloth—and the carpet that covers the table has been pulled up over the front edge as if to emphasize the disarray, setting it immediately in front of the viewer at the same time that it sets the viewer apart.

FYI: **Illustrated books**—In the 1600s, illustrated books were a significant part of Dutch publishing. **Emblem books** were particularly popular. They combined a motto with an image accompanied by a commentary, and focused on the virtuous life and the pitfalls that threatened it. Cesare Ripa's *Iconologia* was allegorical in content, but Dutch emblem books included scenes from everyday life and commonplace objects. **These books supplied Dutch genre painters with images and motifs.** Recognizing this has added to our understanding of genre paintings, but has often led to too specific a reading of paintings. Emblematic literature can be invoked with respect to Vermeer, but because of the poetic nature of his work this can be misleading.

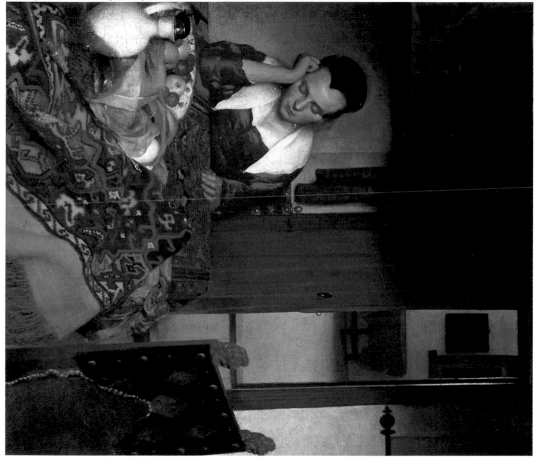

The shadowy painting that hangs just over the head of the sleeping woman indicates a portion of a familiar emblem drawn from the *Amorum Emblemata* of 1608 by **Otto van Veen** (1556–1629). In emblematic literature, this particular image of a Cupid figure bears the motto "Love Requires Sincerity." With the addition of the mask in the corner of the picture-within-the-picture, the allusion is to the deception of a lover. A mood of melancholy prevails. Whether the woman is under the influence of wine and drowsy after a feast, troubled by a lover, or despondent over some loss, her somber solitude is complete. She is a woman alone with her secret thoughts—she is the first Vermeer woman.

Genre Painting and Delft Contemporaries

After the death of Prince William II in 1650, there was an important shift in the direction artists took in their work. Fabritius turned from the Rembrandtesque

to a more original approach to genre subjects, with a studied interest in the architectural settings as a way of enhancing the emotional impact and of deepening the meaning of his pictures.

By 1654, the painter Pieter de Hooch had arrived in Delft, where he developed intimate courtyard scenes and domestic interiors featuring the social interaction of small clusters of figures or mothers and their children. The structure of his images—and in some cases the activity depicted—clearly made an impression on Vermeer and influenced his early genre scenes.

A Seduction Scene

The most apparent influence of de Hooch on Vermeer is in the drinking scenes that Vermeer produced in the late 1650s. *Officer and Laughing Girl* (c. 1658) is a good example. Sunlight glances through the window into a corner of the room, where an officer and a girl are seated at a table, enjoying a glass of wine. The easy conviviality is enhanced by their positioning in the very foreground of the image, but the girl's radiant smile sets the tone above all else. Her smile, her direct gaze, her open hand lying on the table, all indicate that the soldier's charm and the wine are having their effects. The intentions of the soldier seem clear enough from the rakish tilt of his hat, the arm akimbo and jaunty elbow, and the salacious red coat. Vermeer is masterful at integrating the figures into the space, thereby intensifying their connection. He

OPPOSITE ABOVE:
Otto van Veen
Engraving from
Amorum
Emblemata
1608

OPPOSITE BELOW:
Crispin de Passe
Engraving for
Gabriel
Rollenhagen's
Nucleus
Emblematum
1611

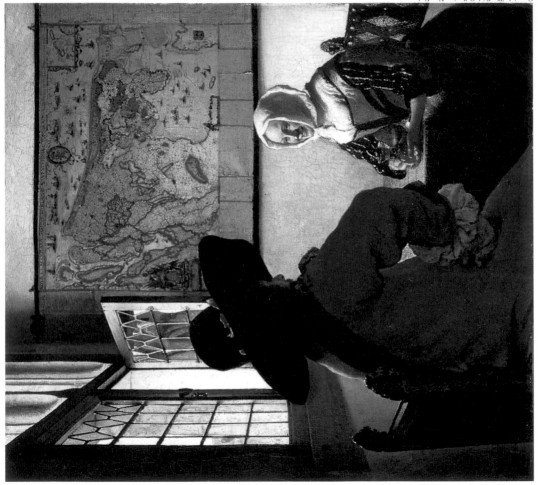

employs a *one-point perspective* (see page 91) without modification, which gives foreground objects (in this case, the soldier) a disproportionate sense of scale, but at the same time heightens the drama. The vanishing point of the perspective lines falls directly in the middle of their mutual gaze, almost adding an exclamation point to the eye contact. The effects of sunlight and shadow and the merely glancing depiction of the soldier's facial features also add to the delicious sense of the moment. The map seen here is based on an authentic one published in 1620, and it appears again in *Woman in Blue Reading a Letter* (on page 68). One wonders impishly if the map is a sly reference to the sexual anatomy.

Dutch genre painting can be divided into peasant genre and fashionable genre. Gerard ter Borch is the major figure working in the latter mode. He developed his sophisticated genre approach after 1650, focusing on ladies in the boudoir, as they receive letters and entertain gentlemen. Ter Borch was less interested in the architectural setting of his dramatic little episodes than in the psychological interplay of the figures represented and in the brilliant rendering of fabrics and other textures.

Two Women

In *Girl Reading a Letter at an Open Window* (c. 1657), Vermeer suddenly strikes the definitive chord that resonates throughout his career. This development happens almost unexpectedly and without precedent,

OPPOSITE
Officer and Laughing Girl
c. 1658
19 $7/8$ x 18 $1/8$"
(50.5 x 46 cm)

and yet it draws in so much of what we understand about the artistic context in which he emerged.

In the 18th century, this painting was attributed to Rembrandt, then downgraded to "in the manner of Rembrandt," and, in the 19th century, it was reattributed to de Hooch. Through the example of Fabritius, we sense the Rembrandtesque quality in the impastoed surface and the warm tonalities, but this quality is modified by the evolution of Fabritius himself. The architecture is an echo of de Hooch, but with more nuance and refinement, and the subject of a woman reading a letter and the rendering of texture remind us of ter Borch. But ter Borch's swooning girls and wary ladies do not prepare us for this detached woman, who is utterly absorbed in some private matter. The curtain mediates the ambiguous space between subject and viewer. The *trompe l'oeil* effect of the curtain was common in Dutch pictures, but the solemnity, the self-absorption, and the solitude of the domestic scene inspire an almost religious awe appropriate to a sacred space.

As if refining the variety of ideas available to him, Vermeer creates a work that seems to flow naturally from *The Procuress* and *A Girl Asleep*. The intervening table draped with an oriental carpet appears again, but the de Hoochlike room farther back is sealed off by the glowing wall parallel to the picture plane. Only the girl's reflection in the window panes offers the ghost of another dimension, but now the deeper interiority is psychic, emotional. The girl is completely enclosed

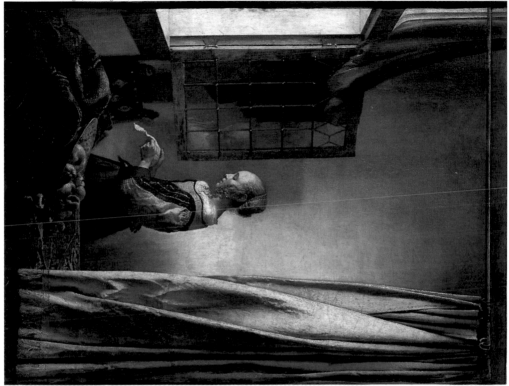

Girl Reading a
Letter at an Open
Window. c. 1657
32 ³/₄ x 25 ³/₈"
(83 x 64.5 cm)

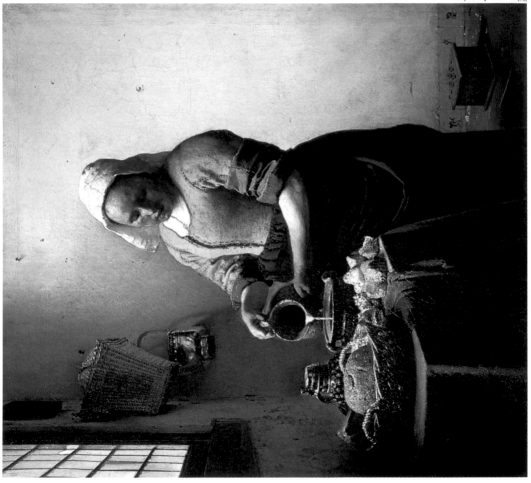

except by the light. The details of daily life and anecdotal purpose of Dutch genre painting have been supremely transcended and Vermeer has found his essential theme.

Sound Byte:

"The innovation of the Letter Reader, the beauty of the deception, is precisely that she offers us no glass of wine, plucks no flower through the casement, casts no shadow across the frame of her niche. She makes no appeal; she claims no place in the tangible world. The whole purpose is to exclude her from it, from the world of touch, a magnetic attraction, to confine her within the envelope of space."

—LAWRENCE GOWING, art critic

The Milkmaid

Soon after painting *Girl Reading a Letter*, Vermeer again broached the subject of a solitary figure—albeit one of a different circumstance in life. The figure has turned, so to speak, from an elegant young woman in profile reading a letter to a plain, humble serving girl performing her duties. In *The Milkmaid* (1658–60), we see the face of the figure almost in full, except for the downward tilt and the slight turn of her head.

Standing alone in a back room bare of decoration, a maid is pouring milk from a pitcher into a bowl. A basket and pail hang from the wall

OPPOSITE
The Milkmaid
c. 1658–60
17 7/8 x 16 1/8"
(45.5 x 41 cm)

and a foot warmer rests on the floor. Light floods into the room through the panes of a leaded window. Sunlight dapples the magnificently painted still life of grainy loaves and various vessels, seemingly to highlight the thin stream of milk.

This is the only painting of Vermeer's that focuses solely on a person of a low social class. The opalescent wall behind the maid radiates with a milky whiteness. The wall is pocked with nail holes, and two nails jut from it in a subtle *trompe l'oeil* effect. The light illuminates the maid's rough, worn clothing and her forearms and ruddy facial features with quiet strength and dignity. The subtle shifting of shadow to light on the wall corresponds to the illumination of the figure from light to dark, highlighting the physical presence of the figure and the quiet enactment of domestic duty.

Vermeer's distinctive, delicate blue-and-yellow color harmony makes its first appearance here. The painter heightens the woman's silhouette with a white line that gives her physical form an almost monumental grandeur. The low horizon line of the perspective creates the effect of looking up at the maid, and enhances the sense of patient monumentality. In an atmosphere of impressive calm, the maid is invested with a *gravitas* that turns the simple gesture of pouring milk into an act of grace. Instead of the often satiric approach taken by fellow genre painters when treating household servants, Vermeer produces an image that is unique in Dutch art: It is an icon of virtue and a symbol of the Dutch character.

Images of Delft: *The Little Street*

Leaving behind the Italianate history paintings of his first works, Vermeer ventured into genre painting, the familiar territory of the Dutch school. But almost immediately he brought to it a quietude and serenity rarely invoked in Dutch domestic scenes. The painting of *A Girl Asleep* becomes ambiguous by the deletion of the typical accompaniment of narrative details. The moral becomes less emphatic, the atmosphere more pronounced. With *Girl Reading a Letter at an Open Window*, the awesome stillness is more captivating than a latent love story. And then, with *The Little Street* (c. 1657–58), Vermeer takes on **architectural painting**, and the serenity of the scene is again pronounced. It is as if Vermeer is exploring his potential as a painter by varying his subjects, and suddenly finds something within himself that expresses his essential artistic personality.

As a scene of daily life, *The Little Street* is utterly serene. A 16th-century house fills the right side of the painting and is linked by a connecting wall to a smaller house on the left. There are two gates in the wall, one closed and one open—revealing a passageway. In the passage, a maid leans over a barrel at some chore. In the open doorway of the house, an old woman sits at her sewing. And in front of the house, at the edge of the cobbled street, two children are kneeling at a game. All of the figures are absorbed in their activities, separate and engrossed, yet in harmony. The scene appears to express the value placed by the Dutch

people on cleanliness, industriousness, and the proper care of children. And the low-key presentation of these virtues on a quiet, tidy street would also speak to the virtue of a well-ordered community under bright but changeable skies.

The painting itself is a marvel of composition, a complex yet rhythmic array of perpendiculars and diagonals, of openings and closures, of surfaces and spaces, and of a subtle balancing act of color. While the scene may be quiet and domestic, the painting itself crackles with life in the meticulous rendering of the weathered brick and mortar, in the silken-threadlike leading of the windows, in the upward thrust of the steep gables against the fluffy white clouds, in the slanting roofs of the houses receding along the left, and in the cascade of ivy. The façades of the houses are parallel to the picture plane and provide Vermeer a complex abstract rectilinear pattern at once sturdy and delicate, but just as rigorous as that of the 20th-century Dutch abstract artist **Piet Mondrian** (1872–1944).

It has been said that Vermeer painted the scene from the second floor at the back of the Mechelen Inn, looking down on a canal and a street called the Voldersgracht. It is clearly apparent in his rendering of the large façade that he made adjustments to it to suit his composition. The red interior panel of the open shutter at the lower right should glance across the doorway where the old woman sits, but Vermeer has widened the wall at that point. He has purposely disregarded the

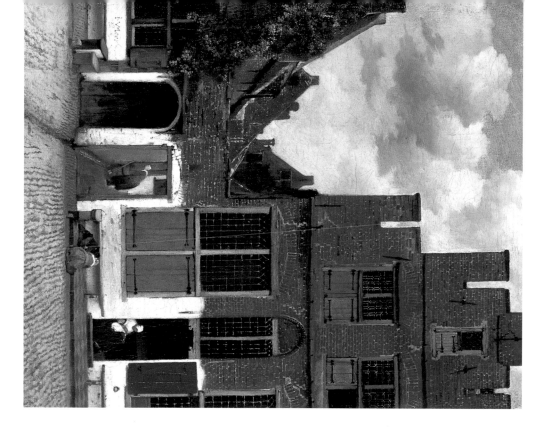

The Little Street
(aka *Street
in Delft*)
c. 1657–58
21 ³/₈ x 17 ³/₈"
(54.3 x 44 cm)

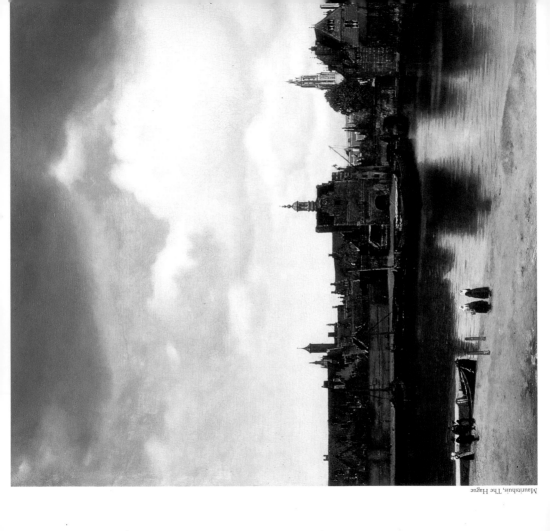

What a View!

Justly famous, *View of Delft* (c. 1660–61) is perhaps the greatest homage to a city ever painted. Since the last quarter of the 15th century, Dutch artists had been painting city views, and Dutch maps often included topographical views of cities—as can be seen in the map in Vermeer's own *The Art of Painting* (on page 88). Vermeer's *View of Delft* belongs to that tradition and represents its climax.

The visible portion of the city lies across the canvas like a dense frieze encrusted with semi-precious stones. The spires of the Old Church (Oude Kerk) are barely discernible above the roofline to the left; the New Church (Nieuwe Kerk), the symbolic heart of the city and site of the tomb of William I of Orange, is plainly visible as it rises above the trees and

symmetry of the actual façade in favor of the red patch with a whitewash nimbus, so as to punctuate the right margin of the composition and set up a vibration with what would have been the green of the ivy along the left margin. The green coloration has been degraded and now the ivy has a bluish cast.

View of Delft
c. 1660–61
38 3/4 x 46 1/4"
(98.5 x 117.5 cm)

49

rooftops, but appears almost incidentally from the vantage chosen by the artist and then by virtue of its height. Vermeer chose this narrower vista as if to avoid the visible scars from the powderhouse explosion of six or seven years earlier. By showing the city in part, he shows it to us whole and healthy.

We see Delft from the south, from across the waterway that links it to the cities of Schiedam and Rotterdam. The sky is bright but changeable, with clouds scudding across it. A cloud overhead has just passed between the sun and earth and has cast its shadow on the near and far banks and on the city walls. The warm yellow slice of sandy bank on the near shore cuts across the lower margin of the painting. A small cluster of shadowless figures stands to the left near a moored barge. The calm waters between the banks are dimmed by the cloud but still reflect the walls of the city on the far shore, where a few figures can also be seen. In the next moment, this corner of the world could be as bright as the inner city that is illuminated by a full blast of sunlight, but in this moment, and for all the time expressed in this painting, we see the city only through shadow.

The warm umber of the flinty walls is flecked with striations of crusty mortar; the crimson-red roofline extending from the left is pierced by gables and chimneys and by towers beyond, and punctuated by the black panes of dormer windows. The dark, hulking boats and barges moored along the far bank at the base of the city walls are flecked with

granular highlights—especially the boat at the right side of the painting where the globules of light give substance to the shape of the vessel and accent what might otherwise be a leaden patch of painting. We strain to see the hour on the clockface just under the cupola of the Schiedam Gate. Everything seems to have come to a standstill in the sudden pause imposed by the passing shadow.

But the shadows of the foreground give way to the sudden brilliance of the inner city, enclosed by the city walls and receding before the low horizon. We search the gaps in the roofline and between the gates to see the glowing interior. The crimson tiles of the near roofs have turned to a salmon pink in the sunlit interior. A bright patch of yellow wall glows like an ember beyond the Rotterdam Gate. And the spire of the New Church is etched brilliantly against the distant clouds.

In the pictorial map of Delft in Willem Blaeu's *City Atlas of the Netherlands* of 1649, one can find the vantage point from which Vermeer created his image. It is thought that Vermeer used a *camera obscura* (see page 53) to aid in his rendering, although there are many minor discrepancies between *View of Delft* and the actual profile of the city. The evidence of the use of a *camera obscura* is found in the light effects, the brilliant color accents, and the diffused highlights—even in areas cast in shadow. Vermeer was never a slave to the projected image within the *camera obscura*, but rather a diligent observer enchanted by the visual effects it produced.

The Venetian painter **Canaletto** (1697–1768) is another artist associated with the use of the *camera obscura*, but though Venice may be the more revered city, not one of Canaletto's many views of Venice can rival Vermeer's view of modest Delft. Vermeer brings to this portrait of his hometown an intensity at once tactile, visual, and transcendent.

Wine, Women, and Song

Soon after painting the masterpieces *Girl Reading a Letter* and *The Milkmaid*, Vermeer seems to backpedal from the implications of those works, and we find him aligning himself again with his contemporaries in such works as *Officer and Laughing Girl* (c. 1658–60), *The Glass of Wine* (c. 1658–60), *The Girl with the Wineglass* (c. 1659–60), and *Girl Interrupted at Her Music* (c. 1660–61). In these paintings, he takes on the subject matter of the fashionable genre painting that depicts scenes of social life among the upper classes.

The Glass of Wine and *The Girl with the Wineglass* are close variations on a theme. In both paintings the stained-glass window features the figure of Temperance as a cautionary symbol. Wine was regarded as possessing aphrodisiacal qualities; at the very least, it is capable of lowering resistance. In the first picture, the girl is drinking, the glass lifted full to her face, while a young man presides, his hand grasping the pitcher of wine at the center of the canvas. He seems eager that the girl drink the full measure. His intentions toward her are clear, but the

The principle of the camera obscura had first been stated in ancient times, but it would come into common knowledge during the Renaissance of the 1500s. The literal translation of this Latin term is "dark room." The device is essentially a darkened chamber or box with a small aperture. The image of a brightly lit scene outside the chamber is reflected through the aperture onto the opposite inner wall of the chamber, just as in the modern camera. And as in a camera, the reflected image hits the screen as an inversion of the outside scene—i.e., it is turned upside down and reversed. With

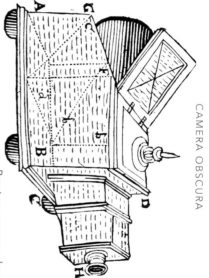

Box-type camera obscura

mirrors positioned inside the camera, the image can be righted and reflected onto a surface for tracing onto a sheet of paper, and although the image can be thus turned right-side-up, it remains reversed. Lenses in a focusing tube can be placed in the aperture to sharpen the reflected image. The chamber version of a camera obscura is useful only to reflect an outdoor scene or landscape, while the box version can be used indoors.

Vermeer may well have set up a chamber version of the camera obscura in the second-

floor room from which he created his view of Delft. He probably used a box or portable version when painting his interior scenes. However, there is no factual record that Vermeer used a camera obscura. The reason critics and scholars believe he did, in fact, use one is because of the visual effects found in his paintings dating from the late 1650s onward. The disproportionate size of near objects—such as the soldier in *Officer and Laughing Girl*—is not a function of the naked eye but rather the effect of seeing through a lens. This is essentially a photographic perspective. Other distortions that would pass without notice in a photograph actually catch our attention in a painting, such as the awkward foreshortening of the hand in *Young Girl with a Flute* or the focal range in *The Lacemaker*, a diminutive masterpiece in which Vermeer's potential use of the camera obscura is most likely. The depth of field, or area in focus, is so narrow that only the silk threads held taut by the lacemaker are in sharp focus.

The most conspicuous feature in Vermeer's paintings that suggests the use of the *camera obscura* is the diffusion of highlights made up of little dabs of paint, or *pointillés*. The reflected image inside the *camera obscura*

not only miniaturizes the scene reflected, but it also intensifies color and highlights and heightens the contrast of light and dark areas. In areas of soft focus especially, there is *halation*, or a spreading of highlights. This visual effect fascinated Vermeer, and we see that he made such paintings as *The Milkmaid* and *View of Delft* sparkle with sequins of light that were probably first observed through a *camera obscura*. But Vermeer was not a mere transcriber or copyist of the reflected image and its effects; rather, he adapted this visual data and exalted it to his artistic purpose.

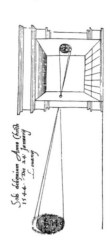

First published illustration of a *camera obscura*

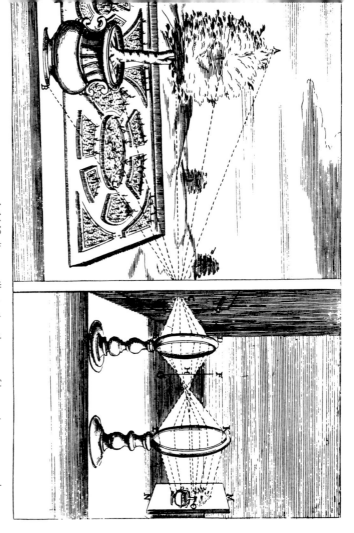

A 1642 diagram illustrating the use of lenses in a camera obscura

orderliness of the room, the elegance of the clothing, the musical instrument and books, and the beautiful compactness of the composition seem to belie the strange mood that prevails. There is something menacing in the directness of his gaze, in the almost malevolent appraisal, and in the fact that, for the moment at least, she is vulnerable.

In *The Girl with the Wineglass* (on page 58), another seduction is in progress. This one, however, is a little more complicated. The figure of Temperance in the leaded window relates to an emblematic image in which Temperance holds a bridle and level or square and bears the epigram "Serva Modum" (i.e., observe moderation), with the accompanying commentary: "The heart knows not how to observe moderation and to apply reins to feelings when struck with desire." But in this painting, there is also a portrait of a forebear or father or perhaps the husband observing the illicit scene in disapproval.

We have to wonder who is managing the situation—the gallant or the girl? We might first think that the girl's expression is addled by wine, but then it seems that this is less the grin of a tipsy girl than the giddy smile of a mischievous young woman testing her powers. She is erect in her chair, self-conscious but apparently in control. The bending seducer may wear the unctuous, patronizing smile of lusty confidence, but it would seem she has something up her sleeve. Indeed, the other young gallant in the room has already been subdued—succumbed to melancholy—having tasted his own medicine.

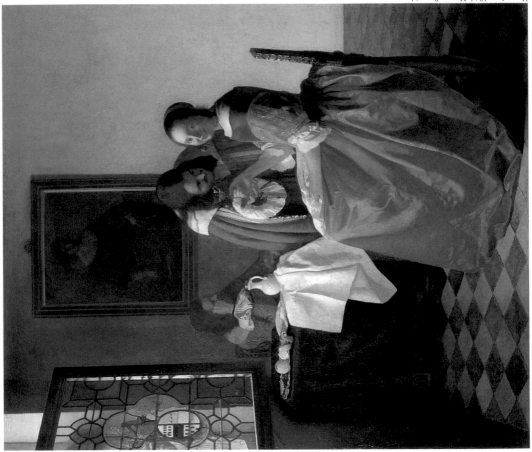

Music as Aphrodisiac

Music was considered another means of altering the mood to advance a seduction. In *The Glass of Wine*, the playing of music was preliminary to the administration of what, in effect, would be a love potion. In *Girl Interrupted at Her Music* (on page 61), the girl is again looking out directly at the viewer, but in this case Vermeer has employed the tactic of interruption to evade psychological and gestural complexities in representing the progress of the seduction. The pause counts for everything in Vermeer—the dramatic stillness, the turbulent quietude, the roaring hush. And although these genre pictures offer something less than the ideal that we expect of Vermeer, they nonetheless prepare the way for the extraordinary painting *The Music Lesson* (aka *A Lady at the Virginals with a Gentleman*), shown on page 62.

At the far end of a sun-filled room, a lady stands playing at a virginal (i.e., a rectangular harpsichord) while a gentleman stands to the side, watching and listening. One can almost imagine him speaking the words of Duke Orsino in Shakespeare's *Twelfth Night*: "If music be the food of love, play on." After the rather tawdry episodes in the previous three paintings, *The Music Lesson* is almost stunning in its virtuous restraint, its elegant propriety, and its masterly resolution of all the formal elements of painting—the structure of the composition, the figures in space, the exquisite rendering, the harmonious color, the flood of light and the play of shadow, as well as the psychology of

OPPOSITE
The Girl with the Wineglass
c. 1659–60
30 $^{3}/_{4}$ x 26 $^{3}/_{8}$"
(78 x 67 cm)

their interaction, the subtle expression, and the complex but muted elaboration of the theme. All lines of the composition point toward the lady and frame her at the center of attention.

The nature of the relationship of the man and woman cannot be known, although traditionally it was believed that the man was her music instructor. It is the pleasures and sorrows of love that are the central theme of the painting. On the inside lid of the virginal is an inscription that reads: *musica letitiae co[me]s medicina dolor[um]* [music is the companion of joy, soothing for sorrow).

Indeed, the painting that hangs behind the gentleman is *Roman Charity*, in which a bound slave receives the charitable, nourishing caress of a saintly woman. But the caress is cropped from the present picture, and only one instrument is played, while the reflection of the woman in the mirror may also suggest that her thoughts are elsewhere. We sense in the separation of the two figures that the lady holds herself aloof from the rapt gentleman. Vermeer also offers a tantalizing glimpse of his own presence in the room: At the top of the mirror intrude the legs of the artist's easel.

OPPOSITE
Girl Interrupted at Her Music
c. 1660–61
15 ¹/₂ x 17 ¹/₂"
(39.3 x 44.4 cm)

Sound Byte:

"I'd give the whole of Italian painting for Vermeer of Delft. Now there's a painter who simply said what he had to say without bothering about anything else. None of those mementos of antiquity for him."

—PABLO PICASSO, May 14, 1935

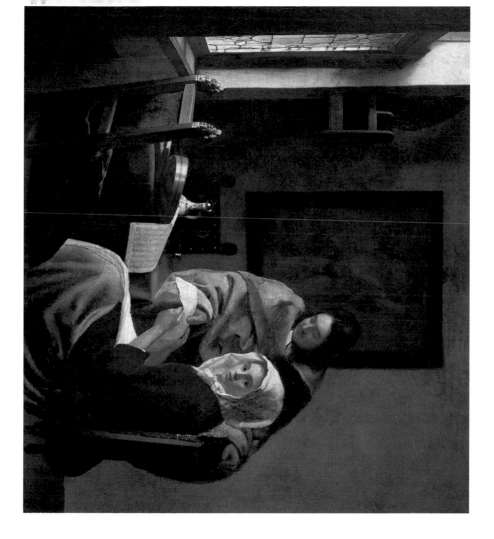

With its three figures as well as the three paintings within the painting—two landscapes and Dirck van Baburen's *Procuress*—Vermeer's *The Concert* (on page 65) is a musical ménage-à-trois that poses an intriguing variation on the theme of music and love with its twining allusions to chaste and profane love. The Baburen on the wall is a leering, raucous echo to the poise of the figures depicted. Despite the subject and the richness of suggestion, the painting maintains a dusky silence as to the relations among the man and the two women. This work was stolen from the Isabella Stewart Gardner Museum on March 18, 1990, along with several other works of art—including two Rembrandt paintings—and its present whereabouts remains a mystery.

There are fewer than 40 paintings attributed to Vermeer, and so in the course of his career he produced an average of no more than two paintings a year. In signing documents, Vermeer always gave his occupation as artist, but it is clear he supplemented his income by continuing to deal in paintings by other artists, as his father had done.

Solitary Women

In the early 1660s, Vermeer embarked on one of the most beautiful series of paintings ever produced. This period of his work could be called *the essential Vermeer,* for these paintings suggest how we perceive all his work and inform how we imagine him and his temperament. Each painting of the series is a work unto itself and yet resonates eloquently

OPPOSITE
The Music Lesson
(aka *A Lady at the Virginals with a Gentleman*)
c. 1662–65
28 7/8 x 25 3/8"
(73.3 x 64.5 cm)

with the others and seems to develop naturally from them. The exact sequence is not known, but scholarly judgments have determined the dating followed here.

These paintings in their subject matter and scale are not at variance with those of other Dutch artists of the time. Similar subjects can be found in any number of works by other Dutch masters and yet Vermeer transcends the conventional genre picture and achieves something much rarer. What do these paintings have in common?

■ a pensive woman alone in the corner of a room

■ sunlight entering from a window on the left

■ a draped table in the foreground

■ a map or painting on the rear wall

■ chairs with lion-head finials

■ pearls on the table or adorning the woman

■ an atmosphere of stillness and quietude

■ a sense of poise, reserve, and self-knowledge

■ an air of serenity and often of expectation

■ a sense of time transfixed

OPPOSITE
The Concert
c. 1665–66
28 1/2 x 25 1/2"
(72.5 x 64.7 cm)

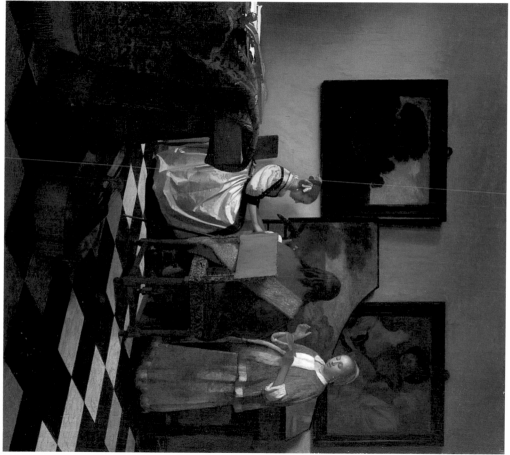

We know only a few meager facts about the period in Vermeer's life when these paintings were made. By this time, he and his wife Catharina and their children were probably living in the house of his mother-in-law, Maria Thins, on the Oude Langedijck in the Papists' corner of Delft.

In 1663 or 1664 his first son, Johannes, was born. Also in 1664, Vermeer was mentioned in the membership of the Delft militia. In 1667, the poem by Arnold Bon praising Vermeer as the artistic successor to the late Carel Fabritius was published in Dirck van Bleyswijck's *Description of the City of Delft*. And on July 10th of that year, he and Catharina buried an infant son in the New Church in Delft.

Where Have All the Children Gone?

It is tempting to imagine that Vermeer's domestic life was as tranquil as the world depicted in the forthcoming paintings, yet he banished his many children from virtually all his paintings. In fact, the only picture in which children appear is *The Little Street*, in which the boy and girl are seen playing.

Detail from the registration book of the Guild of Saint Luke showing Vermeer's signature (#78)

"They are all fragments of the same world: a world that is always—with whatever genius it is re-created—made up of the same table, the same rug, the same woman, the same fresh and unique beauty."

—MARCEL PROUST (1871–1922), French novelist

The scene of a woman reading a letter is common in Dutch art, but *Woman in Blue Reading a Letter* (c. 1662–64) is anything but common (on page 68). It is one of Vermeer's masterpieces. A solitary woman stands alone at the center of the painting. With an intense concentration and perhaps expectation, she is reading the second page of a letter. The first page has already been set down on the table in front of her. She is as still as a statue. Her hands grip the page, her head bowed slightly, her lips parted as if to mouth the written words. Vermeer tells us just enough, but no more. The two chairs suggest an absence, but also the reading of a letter is associated with an absent lover, and the map enhances that meaning with the suggestion of someone on a journey. The pages of the letter are of a similar ocher-yellow color to the sheet on which the map is printed, and just as the creases and dents in the map rise and fall in light and shadow, the folds of the letter reach across the terrain of the lover's journey.

The woman reveals nothing of her emotion, but we surmise by the swell of her figure that she is pregnant. Vermeer suggests an intensity

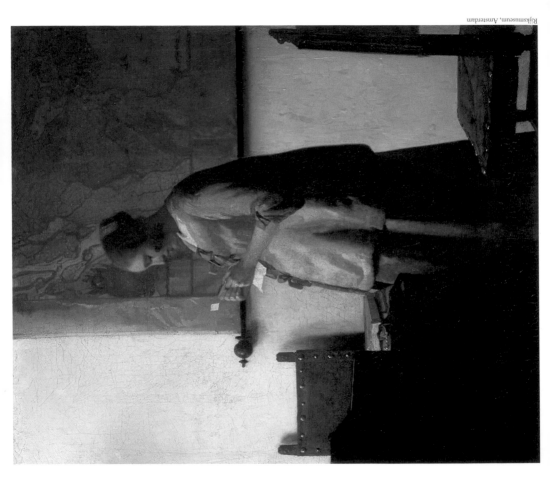

of feeling more powerfully by her restraint than by any outward show of emotion. She is stable, strong, and immobile, but not static. The gentle slope of her silhouette is set in a compositional structure that frames her figure and her solitude with immaculate proportions.

The balance of planes—the map, the sections of the wall on which the light enters from the left and gradually diffuses, the back panel of one chair, the seat of another, and the solid dark mass of the draped table—hold her figure, if not her thoughts, in place. The calm grandeur of the woman and the serenity of the scene are nurtured by the delicate blue tonalities of her house coat, of the seat and back of the chairs, and of the cloth on the table. With Vermeer's sensitivity to optical effects, the blue is even picked up in the shadows on the wall.

OPPOSITE
*Woman in Blue
Reading a Letter*
c. 1662–64
18 1/4 x 15 3/8"
(46.5 x 39 cm)

Sound Byte:

"Do you know a painter called Vermeer, who, among other things, painted a very beautiful and pregnant Dutch lady? The palette of this remarkable painter is blue, lemon yellow, pearl grey, black, white. Of course, all the riches of a full palette are there too, in his rarely encountered pictures, but the combination of lemon yellow, pale blue and pearl grey is as characteristic of him as black, white, grey, and pink are of Velázquez."

—VINCENT VAN GOGH, fellow Dutch artist, 1888

The aura of mystery and profound suggestion in the series of paintings of solitary women is deepened and extended by *A Woman Holding a Balance*. In this work, the light is dimmed and only a soft glow of filtered sunlight penetrates the curtained room. Shadows envelop the scene. In each of the paintings of the series, the setting is the same corner of the same room, but here, in the dusky chamber, we sense a kind of alchemic transaction taking place. The quiet domestic scene is enlarged by cosmic force in the hint of allegory found in the few telling symbols.

On the table before the woman lie the riches of the world, and behind her on the wall, paralleling the picture plane, looms the Last Judgment. The awesome scene, perhaps a painting from Vermeer's stock of pictures by other masters, is rendered in black and ocher yellow. It fills the upper-right quadrant of the painting and frames the woman's figure and her thoughts. Her left hand rests on the edge of the table that defines the lower left quadrant of the painting, and in the dark space between, at the center of the image, the lady delicately holds aloft a balance. Its central place accentuates the exquisite equilibrium of the composition and underscores the meaning of the picture. The balance hangs from between the thumb and forefinger of her right hand. On the wall before her hangs a mirror that could suggest either vanity or self-knowledge, but her eyes are downcast in contemplation of the scales.

OPPOSITE
A Woman Holding a Balance
c. 1662–64
16 3/4 x 15"
(42.5 x 38 cm)

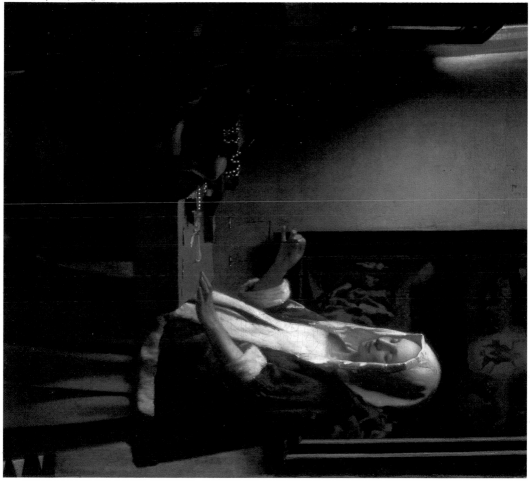

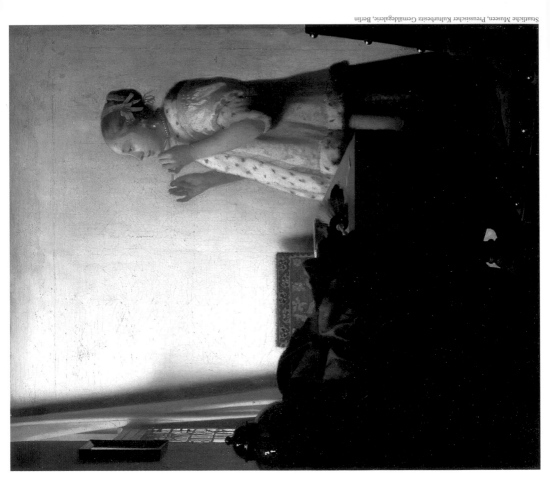

Tradition holds that she is weighing gold or pearls, but close examination reveals the pans to be empty—unless perhaps filled with the vaporous stuff of souls. For to weigh is to judge. But here the balance is in perfect alignment, the woman is serene in her contemplation of the world and of the afterlife to come.

Absorbed in Thought

Vermeer again develops the theme of self-knowledge, but of another kind, at a different stage of life, in the painting called *Woman with a Pearl Necklace* (c. 1664). Here, a girl stands before a table on which lie a brush and basin, a gathered cloth, a Chinese vase, and apparently a letter. She faces a mirror on the wall opposite and just beyond the mirror a cool northern light pours into this intimate corner through a window, warmed by the graceful golden yellow curtain drawn to the side.

The light illuminates the rear wall against which the still life and figure are silhouetted. She is just putting the finishing touches to her morning toilette. She is dressed elegantly in a yellow satin jacket trimmed in ermine, she has tied a bow in her hair, she has hung pearls from her ears, and she is just drawing tight to her throat the yellow ribbons of her pearl necklace. Her hands are poised upraised, as if in surprise or worship, as she gazes across the empty space in the middle of the painting to the mirror. The lustrous rear wall is almost stunning in its blankness, like a clean slate. Of the mirror we see only a dark

OPPOSITE
*Woman with
a Pearl Necklace*
c. 1664
21 ⁵/₈ x 17 ³/₄"
(55 x 45 cm)

frame and a sliver of silver light. Sunlight from the window illuminates the open face of the girl. She is young, pretty, and perhaps hopeful. Vermeer shows her in a private moment; her thoughts are her own, she is self-aware. Her lips part slightly, just short of a smile, and the light glints on a pearly tooth, just as it does on the pearls of the necklace and earring. There is an air of anticipation activated by her expression and her gesture—perhaps the most dynamic gesture of all of Vermeer's solitary women.

Alone... But Lonely?

The young woman in the painting called *Woman with a Lute* (c. 1664) is again alone, but as in the *Woman in Blue Reading a Letter*, there are references to an absence. As we have seen, music and love are connected. In the dimly lit room, her thoughts are elsewhere as she distractedly tunes her lute. Her intent gaze out the window suggests she awaits the return of a lover.

In *Young Woman with a Water Jug* (on page 76), a woman stands in the corner of a room, and in this little space she almost literally holds the elements of the composition together: Her left hand grasps the handle of the water pitcher on the table, her right hand reaches to the window to open it further into the room, and she stands in almost complete outline against the luminous rear wall, the finial of the map pointing to her. Light entering the window from the left—her right—

OPPOSITE
*Woman with
a Lute.* c. 1664
20 1/4 x 18"
(51.4 x 45.7 cm)

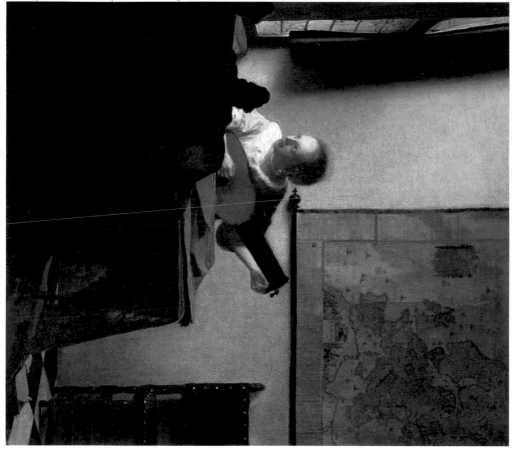

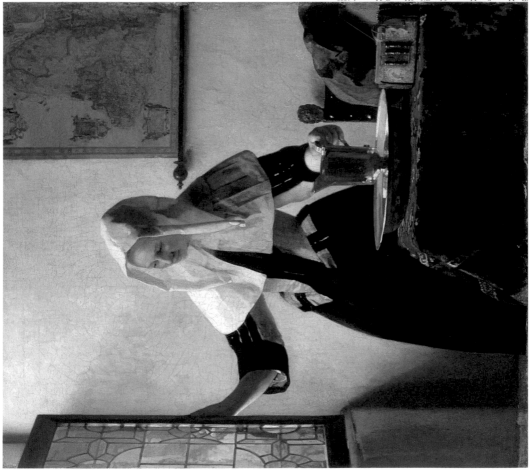

bathes this intimate corner in a gentle cascade, a delicate downward diagonal illuminating her fingertips on the outside of the glass, brightening almost to transparency her collar and headdress, setting the polished metal pitcher and basin aglow, and finally landing in the open jewelry box.

It is an exquisite sonata in blues and yellows, with a refined complementary red in the carpet draped over the table and on the inside lid of the jewelry box. The water pitcher suggests purity, cleanliness. The almost transcendent light reflects on the young woman and radiates from her. She, too, is pure, as if without blemish. She is as lovely as a lily. There is no overt narrative here, despite any intended meaning the painter may have had, yet the power of his image comes forth, luring our attention and arousing a mixture of delicacy of feeling, subtle poetry, quietude, and simplicity.

In another context we would not be surprised to see an angel at the window, for it is almost an Annunciation. Indeed it is tempting to see a symbolic meaning in the light, and the vessel of water, even the open jewelry box—as of a womb. The map of the 17 provinces of the Netherlands on the wall may be a telling clue in that it depicts explicitly only the southern, Catholic provinces. And yet we can be sure that light is the preeminent subject of this masterful work. From the young woman's fingertips behind the glass to the strand of pearls overhanging the jewelry box, a brilliant array of light qualities in interaction with

OPPOSITE
*Young Woman
with a Water Jug*
c. 1664–65
18 x 16"
(45.7 x 40.6 cm)

materiality—transparency, translucency, opacity, light absorption and light reflection—is the all-pervading theme of this most serene work.

Letters...and More Letters

In *A Lady Writing*, Vermeer breaks his pattern of the solitary woman absorbed in thought by having the subject pause in the writing of a letter to gaze out at the viewer. The dimly lit setting is by now very familiar, and the stable composition again assures the pervading sense of quietude. Barely discernible in the painting on the wall is a musical instrument that suggests an absent lover. The glance of the woman would indicate the appearance on the scene of a visitor whose presence does not surprise or disturb—and is not likely the intended recipient of the letter. She is untroubled by this presence. The warmth of her expression and the hint of a smile suggest a simple acknowledgment of mutual understanding. Nonetheless, there is a sense of gravity and deliberation in her posture and in the way her hands are poised on the table. Despite the half-smile, a sadness lurks behind her eyes and in the gloom that surrounds the softly glowing center of the image.

The theme of the letter writer is found in works by other artists, but Vermeers are less concerned with the narrative aspect of the genre than with the poetic resonance of the still, quiet corner and the poised, solitary woman. The trappings are familiar, but here we feel ourselves physically nearer to the lady—no furniture intervenes, only the fall of

OPPOSITE
A Lady Writing
c. 1665–66
17 3/4 x 15 3/4"
(45 x 39.9 cm)

a shadow separates us. The special intimacy of this work is in that proximity and the almost unexpected encounter of her gaze, which allows the viewer a rare sense of complicity in the mystery of Vermeer.

Girls with Pearls

By about 1665, Vermeer completes the series of images of solitary women seemingly transfixed in a moment in time in a small corner of the world. And yet the gravity of those images of private moments of women immersed in thought has resonated down through the centuries and touched a universal quality of feeling, despite the vicissitudes of chance and circumstance that almost obscured forever Vermeer's artistic legacy.

As if painting a coda to his work of the mid-1660s, and perhaps developing it from the intimate contact between viewer and subject of *A Lady Writing*, Vermeer goes on to paint a group of four bust-length portraits of girls in costume.

These paintings are almost a punctuation mark—a sequence of exclamation points—to conclude the series of solitary women. *The Girl with a Red Hat* (c. 1666–67) is a *tour de force* in miniature. The tiny work (9 1/8 x 7 1/8") is painted on a wood panel whose smooth, hard surface does not absorb paint to the degree that canvas does. Thus, the thin glaze rests more on the surface than in other works and obtains a liquidity of light and form unsurpassed in all Vermeer's paintings. Add to that the almost exotic feature of the wide-brimmed red hat and the

The Girl with a Red Hat
c. 1666–67
Oil on wood
panel. 9 1/8 x 7 1/8"
(23 x 18 cm)

classical drape of the girl's blue robe and one senses that Vermeer wished to achieve something extraordinary on the tiny panel.

Here, Vermeer's fascination with optical effects, the colors he employs, and his paint-handling are truly exquisite. Blue and yellow harmonies have dominated in previous works, but in this work Vermeer adds the previously muted member of the primary triumvirate in the brilliant, almost fluorescent red. And he reduces the yellows to gleaming accents on the blue cloth. To punch up the impact of the red he also returns to green, the complementary color to red, in the thin glaze on the shadowed side of the girl's face and in patches of the muted tapestry backdrop. The young girl has just turned and glanced over her shoulder and confronted the viewer—almost with a question. The pose lends a quiet sense of drama to the image. The lion-head finials add to the sense of the encounter. And we are reminded that though Vermeer may have used the *camera obscura*, he does not appear to have felt bound by the outline of its reflections, but was rather enchanted by the optical effects it produced. It seems Vermeer hated crisp lines and never felt that the construction of form should prevail over the dissolving effects of light and shadow. In so many of his works, on close examination one has the sense that they are slightly out of focus. The glaze always overlaps a contour to soften it and bring a vibrant shimmer to the image.

Unlike in previous works, the girl in the red hat is so close to the picture plane—as if captured in a snapshot—that her physical presence

is vivid and alive. The piercing accents of light on the earring and the lips and even in the mouth on the teeth and tongue—and that turquoise dot at the edge of her iris—lend her a palpability that is nonetheless fleeting. Our impression of her is elusive, for she is untouchable. She is a specter of color.

Come Closer...

In the much-beloved *The Girl with a Pearl Earring* (on page 84), the immediacy of expression is more intimate. This young girl in the bloom of youth, looking innocently over her shoulder, seems more physically present. And yet Vermeer has dressed her in such a way as to set her outside time and place. The black backdrop reinforces this sense and at the same time heightens the tangibility of her person. The turban may be called exotic, but the cloth is plain and the wrap is so simple that we don't get the sense that she is in costume or that she has dressed up to impress.

This picture has been called the Dutch *Mona Lisa*. But she is not mysterious in the way that Leonardo's *Mona Lisa* is. One could hardly imagine the *Mona Lisa* or any of Leonardo's figures in real time and space. The mystery of the young girl in the blue turban, as in much of Vermeer's work, is the haunting familiarity, the ineluctable reality that she possesses. Though the black backdrop surrounds her, we see her as if in the full light of day. The parted lips, the wide-open eyes, the creamy,

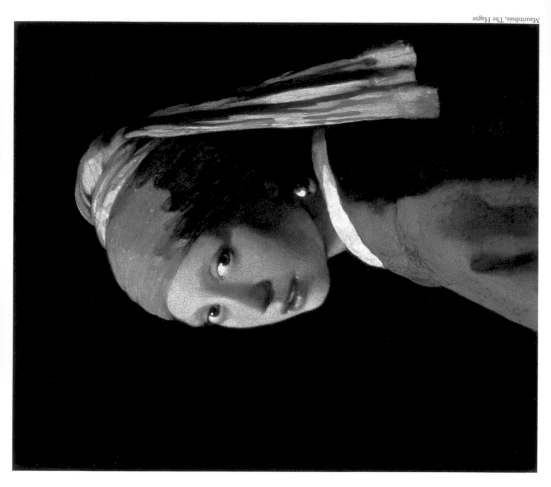

unblemished complexion, all seem to say that she has nothing to hide. The moist highlights at the corners of her mouth glint like dew on a morning blossom. Her purity is so radiant that Vermeer's thin glazes of flesh tone seem to dissolve her features, hovering over the contour of her brow and cheek and chin so that she seems to pulse in the same way that the slightly detectable movement of a hand-held film camera can animate a scene. And she is closer to the picture plane than any other of Vermeer's subjects.

The *Portrait of a Young Woman* (on page 87) is probably the last in the paintings of girls with pearls. Though she is wrapped in a classical robe and intended perhaps for some archetypal role, we feel the distinctive presence of an individual, a person rather than a type. Her face is as soft-colored as a pearl, but suggests a wanness and detachment as of someone frail or sickly. The gnomelike face, the languid half-smile, and the enveloping darkness add to our sense of the mystery of Vermeer.

Vermeer's Women

One can only speculate as to why Vermeer focused his attention so entirely on the subject of women. It is clear from the work, however, that Vermeer had a deep sympathy for the women he depicted. The presence of the artist in these paintings as primary observer is not intrusive, and does not call for the charge of a "transgressive male gaze." It's as if his subjects in their solitude nonetheless feel and accept

OPPOSITE
*The Girl with a
Pearl Earring*
c. 1665
18 1/4 x 15 3/4"
(46.5 x 40 cm)

OPPOSITE
*Portrait of a
Young Woman*
c. 1666–67
17 $^1/_2$ x 15 $^3/_4$"
(44.5 x 40 cm)

his respectful presence as something not unexpected—and, by extension, accept the viewers of these paintings as such. It is, rather, the solitary women who seem to take possession of the viewer, allowing for a rare sense of identification with a work of art. This emotional resonance between subject and observer in considering these works must be the best indicator as to Vermeer's regard for the women he portrays.

In 1667, Arnold Bon's poem was published praising Vermeer as the successor to Carel Fabritius, and in July of that year Vermeer and his wife buried an infant son in the New Church in Delft. Two years later, they would bury yet another child in the Vermeer family grave in the Old Church. In May 1669, **Pieter Teding van Berckhout** (1643–1713), a wealthy citizen of The Hague, visited Vermeer and wrote that he had seen "an excellent painter named Vermeer" and "some examples of his art, the most extraordinary and various aspect of which consists in the perspective." He would certainly have seen *The Art of Painting*, which was painted about two years prior to the visit and remained in the Vermeer home until after Vermeer's death.

Allegory #1: *The Art of Painting*

After the profoundly intimate and personal work of the mid-1660s, Vermeer painted a large allegorical work known as *The Art of Painting* (c. 1666–67). It is an ambitious work and may well speak of the artist's growing confidence and an uncanny sense of his own achievement.

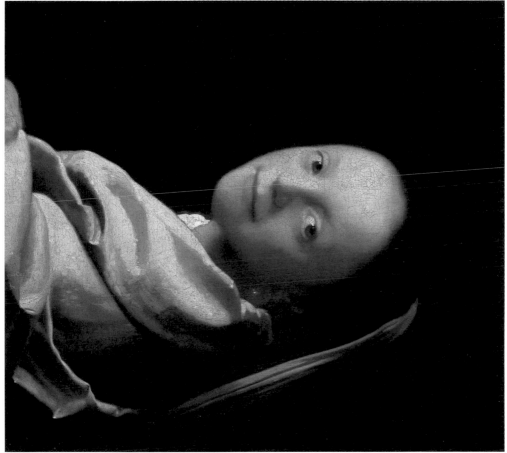

*The Art of
Painting*
c. 1666–67
47 1/4 x 39 3/8"
(120 x 100 cm)

The Art of Painting is a manifesto on the importance of art and the artist in history and to a nation.

Vermeer announces the sense of occasion here by drawing back a heavy tapestry curtain from the scene. It is a set piece. The artist, his back to the viewer, is at work; his model stands before him, armed with the accoutrements of her allegorical role. The girl represents Clio, the muse of History. The horn refers to Glory, the laurel wreath to Fame, and the book she holds—a copy of Thucydides—refers to History. The allegorical signs adorning the young woman are supported by the prominence of the large *Wall Map of the Seventeen Provinces*, 1636, by Claes Jansz Visscher hanging behind her, and by the chandelier ornamented by the double-headed eagle of the House of Habsburg hanging above. These features, underlined by the prominent crease in the map that divides the Calvinist provinces from the Catholic provinces,

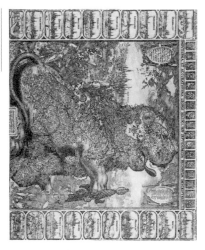

Claes Jansz Visscher
Leo Belgicus, 1609–21
18 1/2 x 22 1/2"
(46.8 x 56.9 cm)

seem to speak of a Catholic loyalty on the part of Vermeer. The richness of the setting, the stage lighting, and the masterful perspective all contribute to the sense of moment.

The usual rectilinearity of Vermeer's composition is given a vibration by an elaborate pattern of striping found in the beams of the ceiling, the stacked town views on the margins of the map, the tiles on the floor, the dark diagonal folds of the curtain, and the jacket worn by the artist. The horizon line crosses the picture plane just below center, along the bottom edge of the map, and solidifies the positions of the subjects and the balance of the composition. The vanishing point is marked just under the right hand of the Muse. Vermeer veils the light source and illuminates the background, while the foreground falls in shadow. The contrast of light enhances the recession of the figures and the spatial depth of the stagelike set.

The painting possesses many of the features characteristic of Vermeer: the veiled personal motive, the domestic interior, the light flooding in from the left, the suggestion of the solitary female figure, the delicacy of her expression, and the all-pervading tranquility of the scene.

The mask lying face up on the table is a sort of surrogate for the missing face of the painter. It may be the death mask that the artist must wear before history can truly record his accomplishments.

PERSPECTIVE

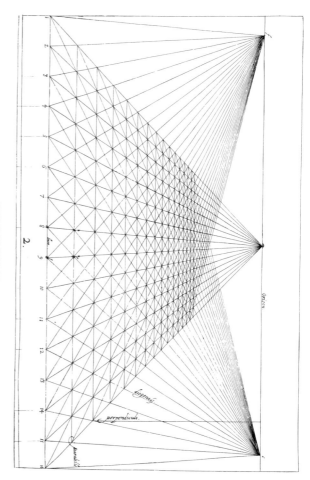

Perspective is the graphic system for rendering the illusion of space on a flat surface, through the diminution of objects, the convergence of parallel lines, and the effect of atmosphere (aerial perspective). Vermeer's paintings are perfect marvels of grace and order composed of the simplest means: a pattern of tiles, a casement window, the corner of a room, a still life, a solitary figure. He routinely established a fixed viewpoint at the level of the windowsill and employed a one-point perspective (i.e., the vanishing point on the horizon line toward which all parallel lines converge) to unify the space and arrange the objects within it. The Dutchman **Jan Vredeman de Vries** (1527–1604?) was the preeminent theorist of perspective in northern Europe—with a particularly marked influence on the Dutch architectural painters. See Samuel van Hoogstraten's A Peepshow with Views of

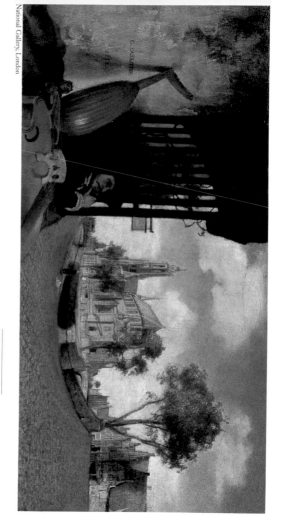

the *Interior of a Dutch House* (left) for the use of perspective, and see Carel Fabritius's *A View of Delft* (above) for his fascination with optics. Fabritius's painting is not merely a simple pictorial anecdote, but is detached and poetic, and has an appeal less for the subtly told moral than for the timelessness of the image, the exquisite balance of tone and form, and the overall unity of composition. These qualities had a fundamental impact on Vermeer.

ABOVE

Carel Fabritius. *A View of Delft, with Musical Instrument-Seller's Stall.* 1652. Oil on canvas mounted on wood. 6 1/8 x 12 3/8" (15.5 x 31.6 cm)

OPPOSITE

Samuel van Hoogstraten
A Peepshow with Views of the Interior of a Dutch House (detail of the back wall). c. 1658–60
Oil and egg (identified) on wood
23 x 32 x 23" (58 x 81 x 58 cm)

Allegory #2: Allegory of the Faith

Near the end of his career, Vermeer painted the one work now viewed by many as the least successful of his artistic production. *Allegory of the Faith* (c. 1671–74) was probably painted to fulfill a commission received from a Catholic patron or the Jesuits of Delft, who were established in the Catholic ghetto where Vermeer lived at the time and in whose church he worshiped.

The painting follows the general composition of *The Art of Painting*, but *Allegory of the Faith* is the one work by Vermeer that was painted according to a specific iconographic program, and it stands in curious contrast to his other surviving works. Faith is personified by a woman dressed in white, the symbol of purity, clutching her heart and gazing upward at a hanging glass sphere. She is seated on a low dais surrounded by Christian symbols. The setting is probably a reception room in the home of Vermeer's mother-in-law, where he and his family were living. Lying on the floor is the apple, the forbidden fruit of the tree of knowledge, and a serpent—symbolic of Protestant heresy—spitting blood as it lies crushed under a stone, symbolic of Christ as the cornerstone of the church. The crystal sphere that hangs from the ceiling symbolizes the human capacity for faith and the fleeting nature of life.

Despite its departure from our idea of the classic Vermeer, this is beautifully painted and possesses exquisite features, such as the abstract patterning of the carpet draped over the low platform, the veined

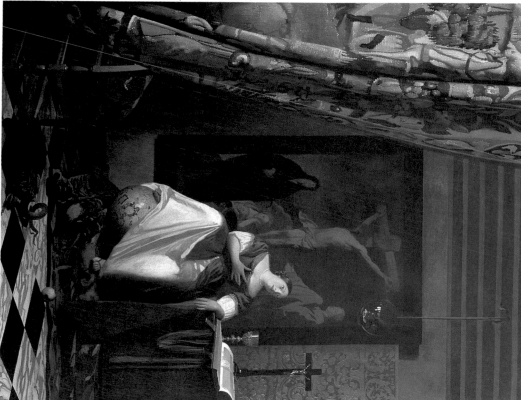

marble tiles of the floor, the light-dappled nap of the curtain, and the light reflections on the jewelry of the emoting girl.

Vermeer's contemporaries may have considered this painting a success, but to modern eyes it is awkward and unsatisfying. It disappoints not so much for the explicit allegorical content or the alarming serpent, but for the bulky figure personifying faith. We have no faith in her; she holds for us no conviction; she lacks the inner life, the presence, and poise of the archetypal Vermeer woman.

The Scholar in His Study

Evidence of Vermeer's interest in scientific knowledge exists in his mastery of perspective, his use of the *camera obscura*, his fascination with maps, and most conspicuously in two companion paintings: *The Astronomer* (1668) and *The Geographer* (c. 1668–69). Astronomy and geography as well as cartography were of special significance to the Dutch, for they were a seafaring nation and their success at maritime exploration and trade depended in part on advances in these fields. The proliferation of maps in paintings by Vermeer and other Dutch artists attests to this. The depiction of a scholar in his study was also common to the Dutch school, especially in the work of Rembrandt and his followers. These are the only two paintings by Vermeer that depict a single male figure. Both show a scholar—the same model—at his work, surrounded by the accoutrements of his research.

The Astronomer is one of only three extant paintings dated by the artist and provides the best evidence for the dating of the last phase of Vermeer's career. As the astronomer reaches for the celestial globe depicting the constellations, a book lies open on the table before him in addition to a compass and an astrolabe, an instrument used to determine the position of the sun or stars. The book has been identified as a work on the observation of the stars by the mathematician Adriaen Metius, published in 1635.

At this time in history, the fields of astronomy and astrology were not entirely distinct, and it has been suggested that the scholar is working out a horoscope. The juxtaposition of two kinds of knowledge, new and old, empirical and nonempirical, earthly and mystic, may indicate an allegorical meaning beyond the portrayal of a scholar in his study. The two paintings depict the life of the mind, the intensity of intellectual inquiry, and the sense that God infuses all of nature. The study of the heavens and the earth thus takes on a theological significance.

It has been suggested that **Antony van Leeuwenhoek** (1632–1723), known primarily for his microscopic studies in the life sciences but also learned in astronomy, navigation, mathematics, and philosophy, may have been the model for these paintings. There is circumstantial evidence of a relationship between Vermeer and Van Leeuwenhoek. Both men were born the same year and the latter worked as a cloth merchant; he may have known Vermeer through his father's weaving

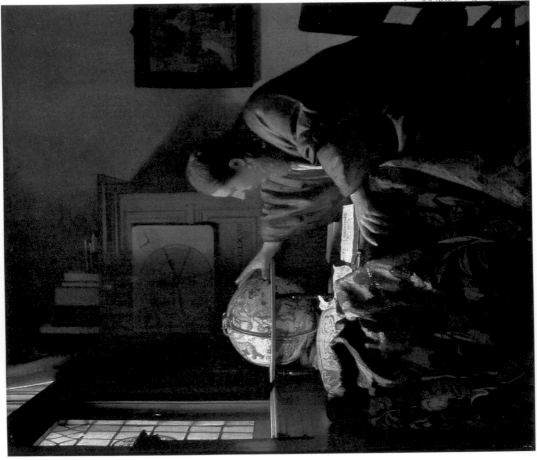

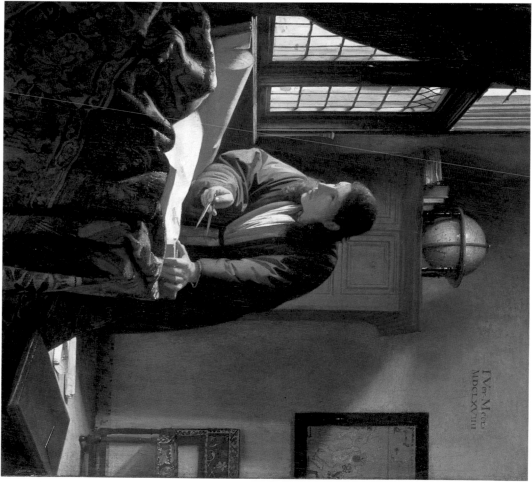

business. But there is no direct evidence of a connection until after Vermeer's death, when Van Leeuwenhoek became the trustee to Vermeer's bankrupt estate.

Last Paintings: Letters and Music

In the late 1660s, Vermeer returned to the theme of the letter, but whereas before he had always depicted a woman alone confronting the contents, he now introduced a second figure, the maid. In three paintings, Vermeer portrayed a mistress or lady of the house receiving or writing a letter with her maid in attendance. The first of these is quite large and—unusual for Vermeer—the space is undefined. In *Mistress and Maid* (c. 1667–68), the figures, set against a darkened background, come right up to the edge of the canvas and are cast in high relief by a bright light.

There is a high degree of modeling in the tablecloth and in the yellow jacket, and yet there is a lovely softness in the features of the lady. Her eye is scarcely indicated and yet we know it is fixed on the letter, the arrival of which has clearly caused consternation in the two women. Their thoughts are racing—the maid is anxious for her mistress and the lady is apprehensive as to the letter's significance. The softness of the lady seems to heighten her sense of vulnerability against the dark background, but in the delicate interplay of light and shade, form and void, fear and hope, mistress and maid, Vermeer leaves the situation

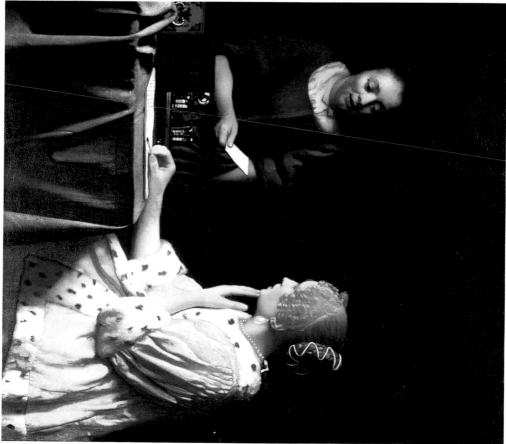

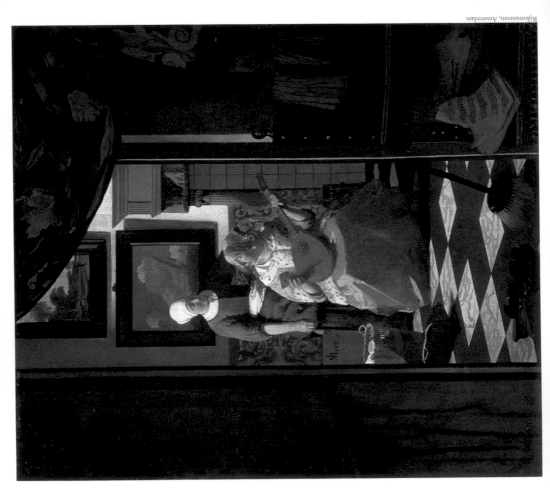

otherwise unexplained and the scene suspended in a dramatic pause, as if at the edge of a precipice.

A Letter, Again

The arrival of a letter is again the theme in *The Love Letter* (c. 1669–70). In this picture, the lady of the house has been playing a stringed instrument and has apparently been neglecting her household duties, judging by the disarray around her. She has been caught by surprise at being handed the letter, and looks up at her maid with concern in her eyes and a question poised on her lips.

However, unlike the previous painting, Vermeer gives us an indication as to a happy consequence. The benevolent smile of the maid and the paintings above the lady's head suggest that all will be well. The seascape indicates smooth sailing and the idyllic landscape above the marine picture seems to confirm the suggestion.

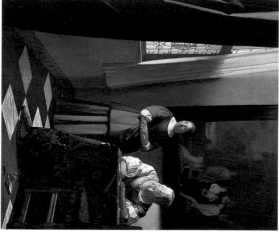

Collection Sir Alfred Beit, Blessington, Ireland

ABOVE
Lady Writing a Letter with Her Maid
c. 1670. 28 x 23"
(71.1 x 58.4 cm)

OPPOSITE
The Love Letter
(aka *Woman Reading a Letter*). c. 1669–70
17 3/8 x 15 1/8"
(44 x 38.5 cm)

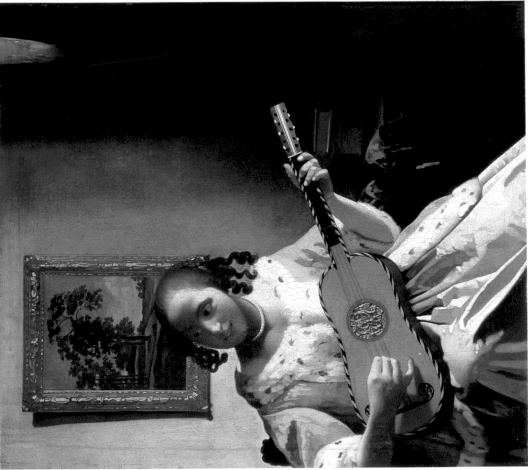

The Last Phase

The Guitar Player (c. 1672) and *The Lacemaker* (c. 1669–70) are two of the gems of Vermeer's last phase. But whereas the latter picture is a study of silent concentration and domestic virtue, the girl playing the guitar is alive with the fresh vivacity of an adolescent whose thoughts have turned to love. As if to emphasize her vitality, Vermeer has placed

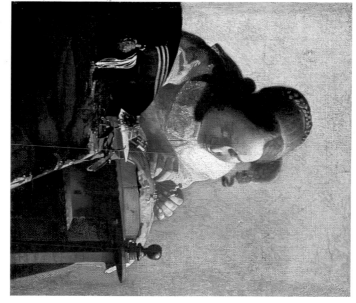

LEFT
The Lacemaker
c. 1669–70
9 5/8 x 8 1/4"
(24.5 x 21 cm)

OPPOSITE
The Guitar Player
c. 1672
20 7/8 x 18 1/4"
(53 x 46.3 cm)

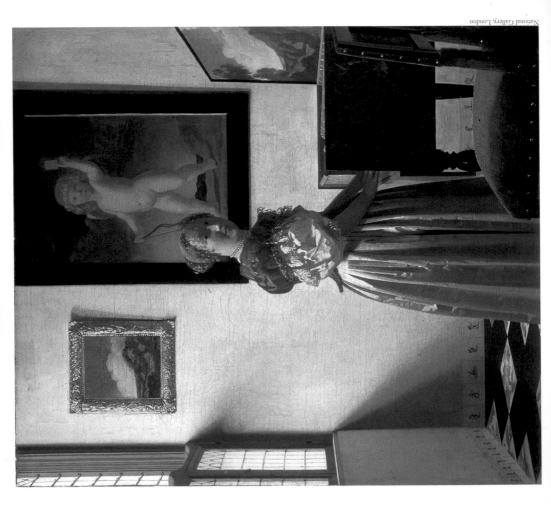

her off-center and in the very foreground. The work is an excellent example of Vermeer's late style and his more abstract treatment of form, with crisper lines and sharper contrasts of light and dark.

Virginals Anyone?

In Vermeer's last two paintings—*A Lady Standing at the Virginals* (c. 1673–75) and *A Lady Seated at the Virginals* (c. 1673–75)—he returns to the solitary female figure, but in each case the woman looks out directly at the viewer. (Recall: A virginal is a rectangular harpsichord.) The twining themes of love and music are again at play, but the images have not the muted poetry and beckoning mystery of the works of the 1660s. These last paintings are harder, more brilliant, and jewellike. The thin atmospheric glazes of previous years have given way to bold strokes of color over sharp contours, which result in a greater clarity of form. This is no longer the shadow world of private thought and feeling, but rather a more public face of feeling, virtue, and beauty. The works are richly decorative and present a world of material luxury graced with light and imbued with the claims of ideal love.

In *A Lady Standing at the Virginals* the woman stands at the instrument in an elegant gown, adorned in both real pearls and pearls of light. Her fingers lightly touch the keys. She is statuesque in her calmness and smiles softly but confidently. The virginal, as the very name indicates, is a symbol of pure love. The Cupid on the wall, which we have seen

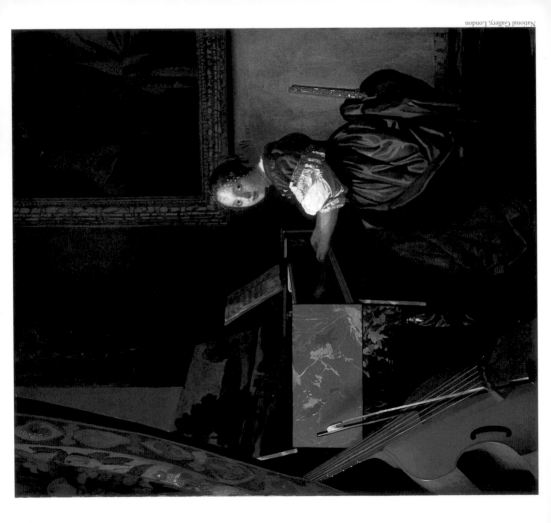

before, again reminds us that true love is for one person only. The landscapes on the wall and on the lid of the virginal speak to the natural beauty of a chaste woman. The candor of her gaze places the viewer in the exalted position of the lover.

Looking at the figure in *A Lady Seated at the Virginals*, one wonders if the model was once the girl who posed for the picture of a girl in a blue turban. She would be about ten years older now and the innocent beauty of girlhood would have been transformed into the stirring beauty of a young woman with the world before her and choices to make. The path lies before her in the landscape painted on the lid of the instrument at which she plays. As we know, the virginal refers to chaste love and the viola da gamba alludes to a lover. Vermeer offers up the contrast of sacred and profane love. This is thought to be the last painting by Vermeer.

Death of the Artist

The 1670s were hard on the Vermeer family. Vermeer's mother died in early 1670 and was buried in the New Church, only to be followed a few months later by Vermeer's sister Geertruijt. Vermeer inherited 148 guilders and Mechelen, the inn that he would later lease out. In 1670, he was elected to a second two-year term as head of the Guild of Saint Luke, but this was not a remunerative position. Two years later, Vermeer and fellow Delft artist Johannes Jordaens were called to The

OPPOSITE
A Lady Seated at the Virginals
c. 1673–75
20 1/4 x 17 7/8"
(51.5 x 45.5 cm)

Hague to give expert testimony as to the quality of a group of paintings supposedly by Italian masters that were being considered for purchase by the Elector of Brandenberg. The two declared the paintings "great pieces of rubbish."

The French army marched into the Netherlands in 1672, and the Dutch, in an effort to stem this invasion, opened the dykes and flooded the land. Vermeer was sinking into debt and another child died. In July 1675, Vermeer traveled to Amsterdam to borrow more money. In December he was dead. He was buried in the Old Church on December 16, 1675. He was 43 years old and left behind a wife and 11 children.

Plagued by debts, Catharina went into bankruptcy and was forced by court order to sell her husband's paintings and other possessions at public auction. Her efforts to retain *The Art of Painting* in the family by transferring it to her mother as payment of a debt was thwarted by Antony van Leeuwenhoek, the court-appointed executor of Vermeer's estate. Vermeer's paintings were dispersed, and gradually he was forgotten.

A Giant Awakens: Rediscovery of Vermeer

Vermeer languished in obscurity for almost 200 years. In that time, there were infrequent brief mentions of Vermeer, usually no more than a listing when a rare painting came up for sale; otherwise, he was unremarked and unknown. But soon after the invention of photography

*Young Girl with a
Flute.* c. 1666–67
Oil on wood panel
7 7/8 x 7"
(20 x 18 cm)

and coinciding with the beginning of French Impressionism, he was rediscovered by the world at large. The French writer and critic known as **Thoré-Bürger** (1807–1869) first saw *The View of Delft* by "Jan van der Meer of Delft" at the Mauritshuis Museum in 1842 while on a visit to the Netherlands. He was deeply impressed and curious because he had not known of the artist before; thus he began his research on Vermeer. In 1849, he was exiled from France for revolutionary activity and then spent much of the ten years of his exile wandering the museums of Europe searching for works by Vermeer

and developing a catalogue of the paintings. He published a series of articles and a book on Vermeer in 1866 that had an immediate impact on the public. People were intrigued by the art of the man Thoré-Bürger called the "sphinx of Delft." Soon, many works were emerging from obscurity, some being reattributed to Vermeer after having been credited to more fashionable artists from among his contemporaries. Of the works now attributed to Vermeer, as many as two thirds of them were rediscovered by Thoré-Bürger.

The rediscovery of the work of Johannes Vermeer coincided with the invention of photography and the beginning of the Modern movement in art. In a sense, modern eyes had adjusted to Vermeer's vision. In addition to the visual aspect of his work, Vermeer brought to painting a secularization of mystery. His suggestion, evasion, and omission stirred modern hearts more deeply than could the elaborate subject matter of an outdated theology. Even while pursuing a realist pictorial vision, Vermeer favored abstract value in form and subject. The beauty and poetic richness of Vermeer's paintings and the haunting aloofness of his persona draw us deeply into his painterly world. Because we know so little of the man, there is not much to contradict the ideal presence of the artist that the experience of his works almost naturally evokes. The paintings are the facts of Vermeer's life. This sense of his presence as well as his absence and the simple human grandeur of the paintings reveal to all of us what seems almost a secret. At once familiar and august, the art of Johannes Vermeer reflects our most profound emotions.

D0481345

ERIN GO BARK!

Irish Dogs and Blessings

A Bark & Smile™ Book

Photographed by Kim Levin
Written by John O'Neill

**Andrews McMeel
Publishing**

Kansas City • Sydney • London

To our dads, whose love of the Irish
(and dogs) inspired this book

Andrews McMeel Publishing, LLC
an Andrews McMeel Universal company
1130 Walnut Street, Kansas City, Missouri 64106

www.andrewsmcmeel.com
www.barkandsmile.com

14 15 16 17 18 SHO 10 9 8 7 6 5 4 3 2 1

ISBN: 978-1-4494-6492-9

Book design by Holly Ogden

This 2014 edition printed exclusively for Barnes & Noble, Inc.

Attention: Schools and Businesses

Andrews McMeel books are available at quantity discounts with bulk purchase
for educational, business, or sales promotional use. For information,
please e-mail the Andrews McMeel Publishing Special Sales Department:
specialsales@amuniversal.com.

Preface

♣

It seems fitting to share the history behind *Erin Go Bark! Irish Dogs and Blessings.* We went to Ireland in March 1999. It was a great opportunity to photograph the dogs there and have a few pints of Guinness along the way! We were shocked by how many dogs we saw roaming the streets and countryside. They had a lot of character, just like the dogs in the United States. They were scruffy, wet, and quite independent—many have never seen a leash or collar—but also very loyal and protective.

For twelve days we drove from Dublin to Kinsale to Dingle Bay to Galway, photographing every dog we encountered

along the way. We had the time of our lives, and we even got engaged during the trip. This book is dear to both of us because it will always be a visual reminder of a very special time in our lives.

Thanks to all the Irish dogs and their owners who let us experience Ireland in such a special way. Thank you to Rick for all his time and effort. Thanks to our parents for their love and support. Finally, thank you to Patty Rice at Andrews McMeel Publishing who saw the humor and sentimentality in *Erin Go Bark!*

Erin Go Bark!

May you welcome
the ones you love
and even the ones
you don't.

May your lazy afternoons
stay that way.

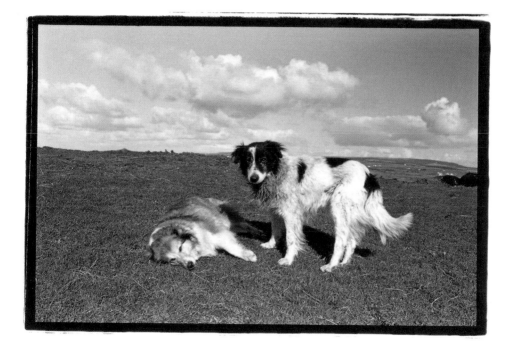

May you always eavesdrop
on good news.

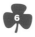

May you seek revenge
on the person
who named you "Scruffy."

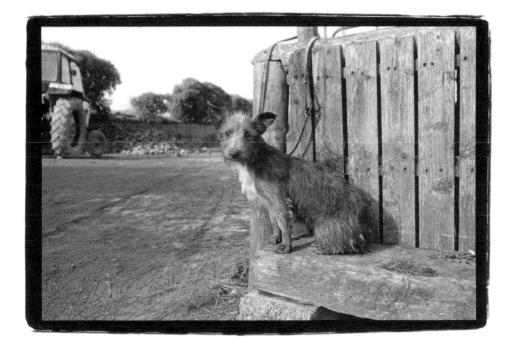

May you see the
inside of the door
as often as you see
the outside.

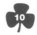

May Mother Nature always
give you the best baths.

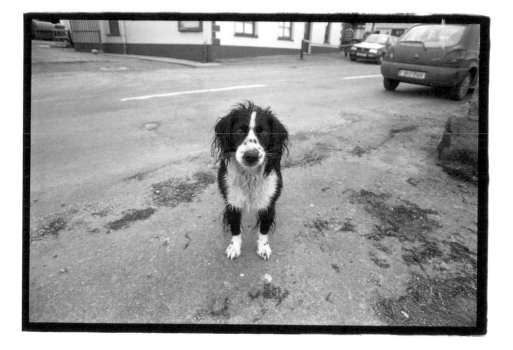

As you perch yourself
on the same old stairs,
may yesterday's woes
be today's love affairs.

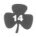

May a doggy bag
always reward your wait.

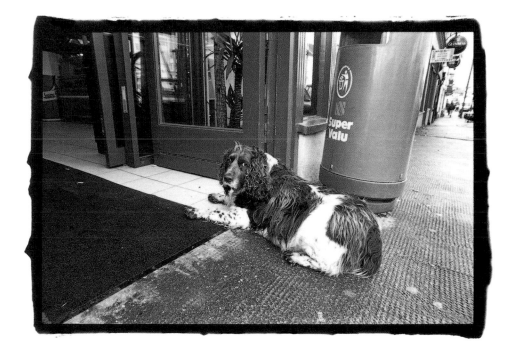

May getting down
be easier than getting up.

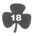

May the person
who brushes your hair
have a gentle hand.

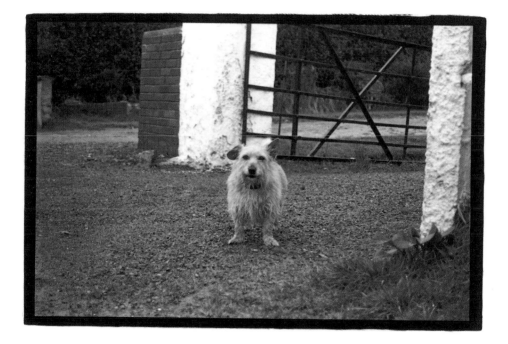

May your paws never slip . . .

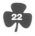

. . . when you stretch.

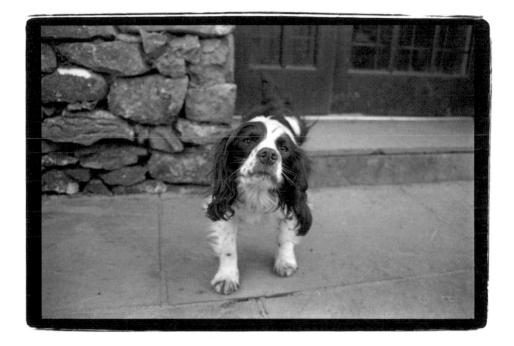

May the sun keep you warm,
and the ground keep you cool.

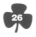

May the feeling of a warm hug
come at least once a day.

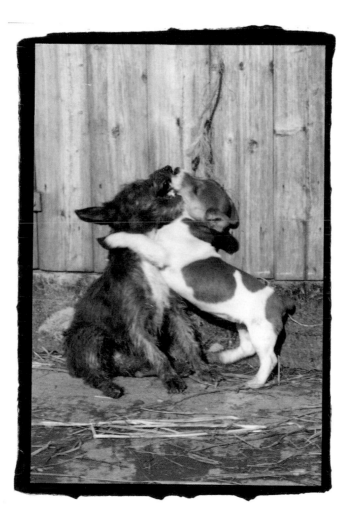

May your walks never end
before you want them to.

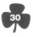

May the next person
who calls you "Lassie"
get fleas.

May you never have
a "nine to five."

May you put a smile on the face
of the next one you meet.

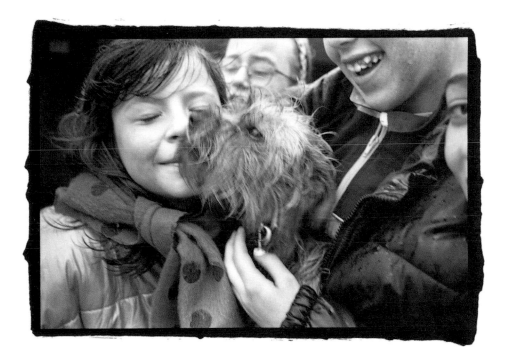

May your legs always remain as strong as your will to run.

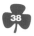

When you're feeling lonely,
may your tail still wag, and . . .

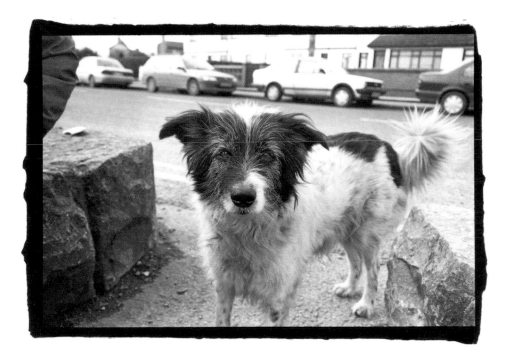

. . . may a new friend
be just around the corner.

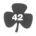

May your local open early
and close late.

May your owner
never play off-key.

Let us forever bless
the witty soul
who invented dog clothing.

48

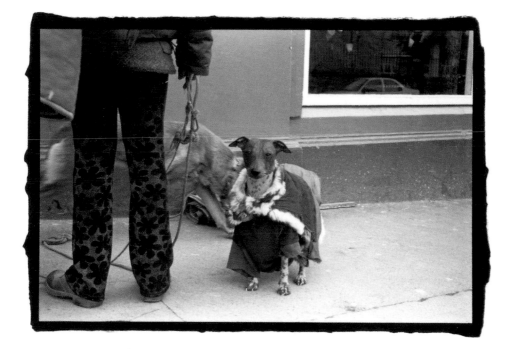

May the smile on your face
get bigger every day.

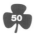

May you always find the time
for family outings.

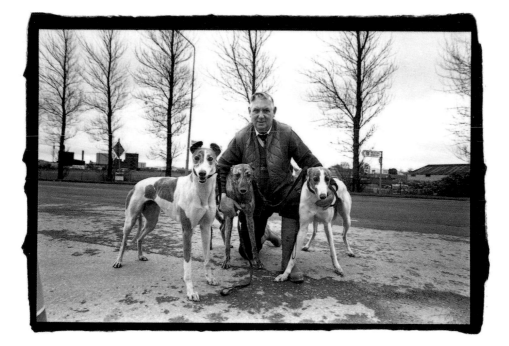

May you leave
a lasting impression
on those who pass you by.

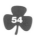

May your bed stay warm,
your bowl stay full,
and may you live
a long and healthy life.

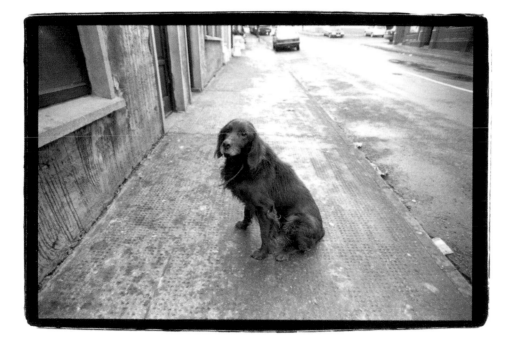

May you always
catch your breath
at the top of the hill.

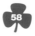

In all that you do,
may you always find
a helping hand.

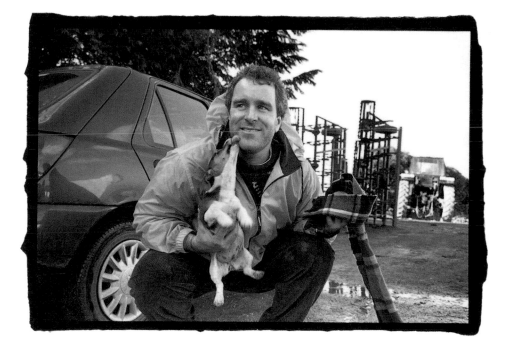

Be curious,
like an Irish rover . . .

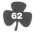

. . . and mysterious,
like a four-leaf clover.

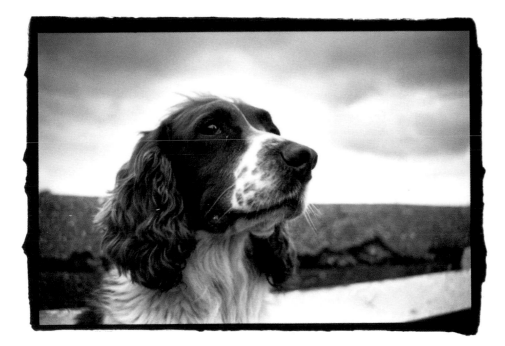

May your coat stay shiny,
your nose stay cold,
and the sidewalk stay soft.

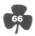

May you never have to worry
about covering your mouth
when you yawn.

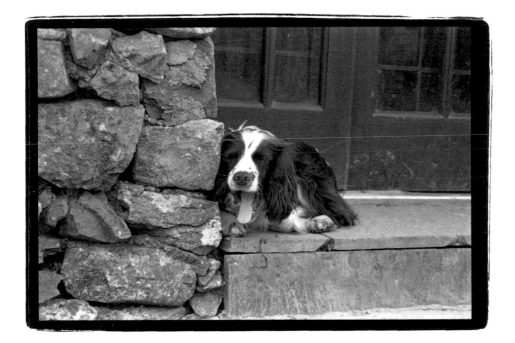

When times get cold and wet,
may your dreams
stay warm and dry.

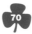

May you always find happiness
on the road less traveled.

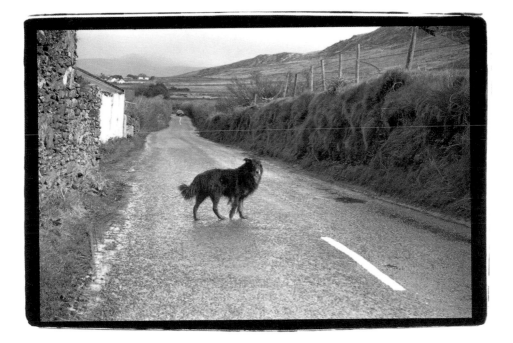

May your friends
always sing your praises
behind your back.

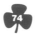

May your ears
never look like this.

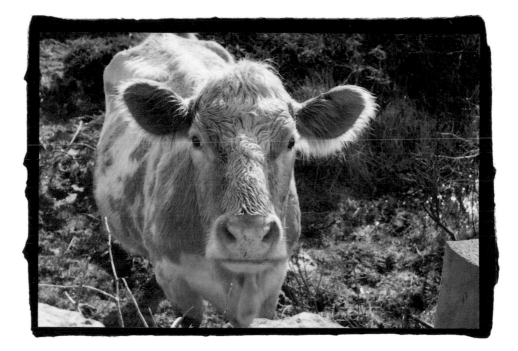

The world is your fire hydrant;
unleash your potential!

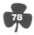

May you never get stuck
at the end of the queue.

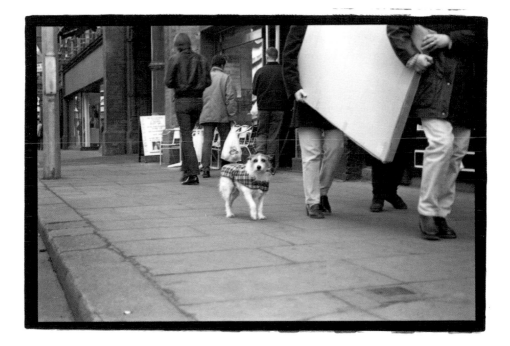

May you never get bored
just shooting the breeze.

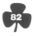

May you always understand
what's being said to you.

May the "big dogs" be careful
whom they mess with.

May the mailman
never keep you waiting.

Erin Go Bark!

Tomorrow

Adventures in an Uncertain World

BRADLEY TREVOR GREIVE

BOK5084

Andrews McMeel
Publishing

Jacuzzi is a registered trademark of Jacuzzi Inc.

Pop-Tarts is a registered trademark of Kellogg Company.

This edition published in 2003 by Andrews McMeel Publishing exclusively for Hallmark Cards, Inc.

www.Hallmark.com

ISBN: 0-7407-4364-3

Book design by Holly Camerlinck

Photographs are used with permission from the following sources:
Auscape International
(www.auscape.com.au)
Australian Picture Library
(www.australianpicturelibrary.com.au)
Austral International
(www.australphoto.com.au)
Bradley Trevor Greive
(www.btgstudios.com)
Getty Images
(www.gettyimages.com)
Photolibrary.com
(www.photolibrary.com)
Stock Photos
(www.stockphotos.com.au)

Detailed page credits for the remarkable photographers whose work appears in Tomorrow and other books by Bradley Trevor Greive are freely available at www.btgstudios.com.

For Douglas Adams

1952–2001

A man who, in but a few short years, managed to fill the world with light and laughter, made the known universe a little bit bigger and a lot more interesting, waded through questions and malt whiskey that would bring tears to the eyes of mere mortals, and still found the time to climb Mount Kilimanjaro wearing a rhino costume.

Tomorrow

After long and thoughtful consideration,
I have come to a rather interesting conclusion.

2

Even though the global population is soaring into the billions,
with thousands of religions, languages, philosophies, and
cultures represented,

3

4 ultimately, there are only two kinds of people.

There are those who are certain the world is going
to hell in a handbasket,

and those who believe the best is yet to come.

(Actually, there is a third kind of person who thinks
traditional Irish dance is the highest form of creative expression,
but I *really* don't want to talk about them.)

7

Now, it hardly takes a genius to point out that we already
live in dangerous and uncertain times. Why, all you have to do
is turn on the TV, grab a copy of the newspaper,

or just take a look out your window.

It ain't a pretty sight.

Best friends and former allies

are suddenly tearing at each other's throats,

while unshakable economic powerhouses
are crashing to their knees on a daily basis. 13

You and I both know that good people get attacked
in broad daylight all the time,

but somehow the bad guys never get caught.

It seems that everywhere you turn there are
psychotic egomaniacs secretly trying to spoil your fun,
drive you crazy, and generally make your life miserable.

Just for starters, there are shop clerks with way too much attitude, 17

doughnuts with too much icing sugar,

unbearably long tap-dance routines in the middle
of your favorite old musicals, 19

and the dramatic aftereffects of a
dangerously authentic chili con carne

that are made ten times worse because
public rest room doors never lock properly anymore!

Of course, heartburn is nothing compared to heartache.
Even though we are frequently told there are
plenty of fish in the sea,

the truth is that most of us spend a great deal of our lives
physically and emotionally isolated, feeling utterly alone.

And if you do finally snuggle up to someone
who seems perfect for you,

you find out they snore so loudly
that your dreams need subtitles.

You just can't win!

If you listen to the professional doomsayers,
they will tell you that's barely the half of it.

They say these are our darkest days,
and the future looks bleaker than ever.

They tell us again and again that evil lurks everywhere—
in the streets, in the trees, in the media, in the air, in the water,
in the corridors of power, even in your sock drawer— 29

waiting impatiently to rise up when we least expect it
and sink its venomous teeth into our most tender regions.

And finally, they point out that at every office Christmas party
there is always someone who feels compelled to do *this!*

"It's the end of the world," they shout. "It's all over!"

Now, what I find so confusing is that if these stone-faced folk truly believe all the scary stuff they preach, why do they choose to keep on living?

33

Okay, I freely admit that choking yourself to death
is not nearly as easy as it sounds,

and I was surprised to learn that you can't actually kill yourself
simply by overdosing on bran fiber, although you certainly
will become embarrassingly regular.

35

36 Luckily, thanks to modern technology, putting yourself out of your misery has never been more convenient or affordable.

Of course, if life really appears that unpleasant and meaningless to you, go see an eye specialist and then take a closer look.

You will find that there is always beauty and hope
in even the most awful circumstances.

There is always someone prepared to help those who ask.

40 There is always someone you can count on,

and there are a million special moments that can chase
the shadows from your face in an instant and will cost you
nothing but a few spare minutes.

41

Furthermore, romance is not dead.
In fact, there are actually more qualified tango instructors
working today than at any other time in history.

The odds of an unexpectedly intimate Jacuzzi encounter
have also never been better.

Although it may not be on your mind right now, the wisdom you
glean from your joys and hardships can always be shared with
someone else and, by doing so, you will leave the world
a little better than when you found it.

Even though I think life is infinitely more preferable to the alternative, I'm not pretending it's always easy or enjoyable. The truth is that sometimes life is so damned hard it gives you a cramp in your brain just thinking about what you have to do to make it through another twenty-four hours.

45

So it's no surprise that when they think about the future,
a lot of people feel anxious, somewhat depressed,
and generally confused and alarmed.

Even in the best of times there will never be a shortage of
moaners and grumblers, but it's always fascinating to see how
different people react during times of genuine uncertainty.

There are those who completely flip out
at the very first rumor of trouble

and start screaming, "The sky is falling, the sky is falling!" 49

But when you press them for hard evidence to explain their panic, they admit they have nothing better to back up their position than what "a little bird told them."

Somehow, it never occurs to them to wonder how credible
the little bird's source was in the first place.

Then there are the people who put on a big show about how they are not concerned in the least and know exactly
what to do about everything,

but when they are alone at night and the lights go out,
they may well be the most frightened of all.

There are also plenty of folk who are absolutely certain that the future is an extremely hostile place, no matter what you show or tell them. They stand ready to defend themselves
from a million dangers every day,

until eventually they become as hard, ugly,
and cruel as the world they have imagined.

And finally, there are people who just want to dig an emotional bunker and jump inside. They think if they put up enough walls, they'll always be safe.

The irony is that instead of locking others out, they are actually locking themselves in. They may avoid a few things that make life difficult, but in the end, they also miss out on all the wonderful things that make life worth living,

57

and that makes about as much sense as
practicing high fives on your own.

A far more reasonable approach is simply to put on
the bravest smile you've got

and admit that you are not the center of the
known universe. Therefore, there will always be things
you don't know and can't control.

So when it's simply not your day and things get a little out of hand,
as they invariably do from time to time, 61

it's much more productive and far healthier to just sit back
and enjoy the absurdity of the moment.

This is not rocket science. It's just common sense that you should enjoy the bizarre fact that you live on a planet with at least six hundred unique flavors of ice cream,

instead of getting all worked up about the truly disgusting taste of "atomic lemon sherbet with licorice ripple."

Likewise, it's definitely not worth obsessing about the intentions
of all the sinister individuals who stalk the earth.

When it comes to ne'er-do-wells who betray and hurt others
for their own personal gain, their wicked ways eventually catch up
with them. They pretty much always get what they
deserve in the end.

So in other words, a good support network is always valuable,
but hiring personal bodyguards is probably going too far! 67

Another reason why you shouldn't fear tomorrow is that although you probably aren't what you eat, you certainly are what you love.

This means that who you really are is always
accurately reflected in everything around you that is dear to
your heart—your close friends being one obvious example.

In this sense, it is fair to say that the world around you is a mirror.
Therefore, you have a lot more control over the future
than you might think, because you can shape your world
just by being true to what you really care about.

Perhaps this will make sense to you, and then again, perhaps it won't.
You might say, "Aha! But how do you explain all the terrible things
in my world that I don't want?" That is certainly a valid question, 71

and my answer is, irritatingly enough, yet another question:
"What is it that you truly want?"

You see, it's what we truly want and love that influences
the world around us, whether we admit it or not.
For example, we often say we just want to be happy,

73

when what we mean is we want money—lots of it.

We say we want spiritual enlightenment and a
higher sense of understanding,

but what we really want are easy answers.

We say that we want love, affection, and companionship, 77

but what we really want is wild, passionate sex.

We say we just want to be accepted for who we really are,

when we really wish we were a little more glamorous

and had slimmer, firmer thighs.

As a rather wise person once said, "You can't fool Mother Nature."
There are certain immutable truths in this world that
you just can't talk your way out of.

Gravity will always get you down,

Belgian chocolates will go straight to your hips,

and sticking your finger in the toaster when your Pop-Tarts are ablaze is always something you'll regret.

Likewise, you must be very careful what you wish for, because you simply cannot lie to yourself and get away with it. When you are not honest about what you want in life, you hurt those closest to you and yourself most of all.

Think very clearly about what you care most about. What is it that gets you excited about being alive? What do you really want to do with the limited time that you have? What will your personal legacy be?

But don't spend all your time dreaming about the future,
because the key to tomorrow is today.

No matter what brilliant answers you have for life's important questions,
ultimately what counts is that you break through the fears
and doubts that hold you back and take action.

Be your own cheerleader.

Do something you never thought you'd ever do—
live in the moment.

Keep in mind, though, that someone else's greatest adventure

could turn out to be your greatest nightmare.

So follow only your own road, wherever it leads you,
one step at a time.

Your life journey is not a race or a competition,
nor is it a boring highway without exits that you must
trudge along for eternity.

Embrace the unpredictable and go exploring
for things that inspire you.

Take time out to enjoy the view.

The fact is that one day, instead of waking up for breakfast,
you will find yourself drawn down a long, dark tunnel toward a bright
and beautiful light, and your journey will have come to an end.

In that moment, when your entire life passes by before your eyes,
I really don't think you will care too much about the amount of
money you made, the frequent-flyer miles you accrued, the awards
you won, the car you owned, the value of your stock, or the number
of times you got your picture in the newspaper.

Instead, I believe the most important things in your life will
probably be the smooches you shared,

the nights you spent gazing in wonder at the stars,

all the funny looking snow angels you made,

the first drops of summer rain caught on your tongue,

and the time that someone special whispered, "I love you."

Don't waste the present worrying about the future.
It will come soon enough—I promise.

105

In the meantime, I suggest you keep your chin up,
put your walking shoes on,

and follow your heart to the ends of the earth.

As you make this journey, always remember that
each day is a precious gift. If you can enjoy it
for what it is and make the most of it,

then believe it or not, there is another
extraordinary gift waiting for you.

Tomorrow.

Acknowledgments

These days I often find myself wondering how so few words could have taken me so far or propelled me into such glittering company. When I look in the mirror, I see only a slightly shop-soiled Tasmanian and not much else. Yet because I have been blessed with the support of my incredible team at BTG Studios, along with the wit and wisdom of publishing luminaries such as Christine Schillig at Andrews McMeel (U.S.A.) and Jane Palfreyman at Random House (Australia), I have been able to accomplish far more that I ever dreamed possible. To these fabulous folk, as well as the passionate publishers and beloved readers throughout the globe who have believed in and enjoyed my humble endeavors, I offer my eternal heartfelt thanks.

As always, I must emphasize that my little books would be nothing without the superb photographs that drive the visual narrative from beginning to end, and I encourage everyone to celebrate these artists and the photo libraries that have contributed to this book by seeking out their contact details posted at www.btgstudios.com.

Finally, I must admit that this book was wholly inspired by the remarkable adventures of my international literary agent and fencing coach, Albert J. Zuckerman of Writers House New York, which took place during a creative workshop/ice-fishing trip in Alaska during the winter of 1967. According to the version shared with me by Professor Stephen Hawking (another Writers House

author), Al was composing an amusing limerick that used all one hundred Eskimo words for *snow,* when suddenly a desperate and breathless harp seal scrambled across the ice and took sanctuary behind his chair, to be followed moments later by a voracious and savagely determined polar bear—the largest of the land carnivores. Without any thought for his own safety, Al hurled Bennett Cerf and Saul Bellow out of harm's way, quickly grabbed a fistful of liberally salted cashew nuts, and rubbed them vigorously across the sensitive eyes and nose of the bewildered she-bear, who soon retreated to plunge her stinging face into a distant snowdrift. Turning to the stunned writers and publishers who lay strewn about the campsite, Al smiled wryly, displayed a single, savory cashew, and announced in perfect Latin, "A humble nut, the salt of the earth, and yet the future of mankind is assured." Since hearing the crude English translation of those immortal words, I have known in my heart that no matter how bad things got the sun would rise tomorrow, and I would be there to enjoy it.

Thank you, Al, for giving us hope. Thank you for giving me a future.

In memory of Biff,

a furry friend to the end